**VIC**

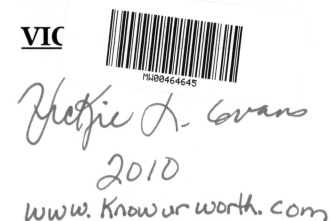

*Victie L. Evans*

*2010*

*www. Know ur worth. com*

# KNOW YOUR WORTH!

### *(Overcoming the Dragon of Low Self-Esteem!)*

# Soaring High Productions
## www.forgiven2.com

Scriptures taken from the HOLY BIBLE, NEW INTERNATIONAL VERSION®. Copyright © 1973, 1978, 1984 International Bible Society, Used by permission of Zondervan. All rights reserved.

Scriptures taken from *The Message*, Copyright � 1993, 1994, 1995, 1996, 2000, 2001, 2002. Used by permission of NavPress Publishing Group.

Scriptures taken from the Amplified® Bible, Copyright © 1954, 1958, 1962, 1964, 1965, 1987 by The Lockman Foundation. Used by permission (www.Lockman.org).

Additional scriptures taken from the King James and New King James Versions of the Bible.

*ISBN-13: 978-0-615-27395-2*

*ISBN-10: 0615273955*

*Library of Congress Control Number: 2008911083*

*Cover Design by: Vickie L. Evans: Source Images - http://www.dreamstime.com/*

*Book Editor: Franci Schwartz*

## Thank you God for entrusting me with the gift of journalism!

This book is dedicated to those who have been battered, bruised, broken, misused, mishandled, and robbed of their sense of worth and wealth by the dragon-like experiences of life! You can be "whole" again!

Special acknowledgements are given to those "warriors" who encouraged me to complete this book in the midst of adversity and kept my "arms" lifted: Mom (Ruby Burrage), Dad (Robert Ellis), Spiritual Mom (Eloise Rump), Daughter (Kyeisha Washington), Friends (Jackie Smith [my Gayle], Teresa Cheeks, Velma Brown, John and Carmen Dorsey, Apostle Linda Hunt, Kim Clark, Loretta Baker, Regina Cherry, Casandra Johnson, Darrell Ingram, Brenda Buckner, Minister Stewart Killian, and Sharon "Cookie" Corcoran).

**YOUR FRIENDSHIP IS PRICELESS.....**

# Table of Contents

# FOREWORD

### *Whom the Son sets free is truly free indeed!*

Indeed, GOD has used Ms. Vickie Evans to expose the lies, tricks, and schemes of Satan! *Know Your Worth! (Overcoming the Dragon of Low Self-Esteem)* is a must read for men and women, young and old, within the body of Christ! This book is designed, by the power of the Holy Spirit to free God's people from the power of low self-esteem.
I myself have been freed from that dragon that held me back, for years.

I know first-hand the damage that the dragon of low self-esteem can have in one's life! As the daughter of a Baptist pastor, for many years, I looked in the mirror and did not like what I saw. For many, many years, I wished I was someone else and I compared myself to family members and others. I, too, had many thoughts of suicide, thinking that it would relieve the pain and the guilt of the wrong choices that I had made in my life.

PRAISE God, I am free from the dragon, and you can be free also, by God's power! I encourage you to give a copy of this book to your family and friends who are struggling and fighting with the dragon of low self-esteem! I praise God for your choice of using this book to slay the dragons in your life.

**Mrs. Brenda Buckner**
**Founder of *Teen Speak, Christians-Together-In-Action*, and *the Master's Touch Mime Ministries*.**

# INTRODUCTION

Ladies, can we talk? I have some things that I want to get off my chest and share! These are strictly my viewpoints but I believe that you will find them helpful and enlightening; you might even agree with them. Let me start by saying that I am not a counselor, nor am I an expert in these matters that I am addressing. However, I can say that I am a woman who has experienced the solitude of singleness, the mayhem of marriage, and the demoralization of divorce. At each of these stages of my life, I have acquired tidbits of knowledge that have added the gray hair of wisdom to my head. Throughout the book, I use four tools to illustrate my viewpoints, all which are integral parts of my life:

1. **Scriptures**: The longer I live, I find that the Word of God is applicable to **EVERY** situation in my life and if you seek an answer; you will find it! In my opinion, the Psalmist, King David is the greatest war strategist, leader, and poet that have ever lived. Queen Esther inspired me to embrace my physical beauty and inner strengths, and Judge Deborah enforced my belief that a woman can do anything, when she makes up her mind.

2. **Songs**: I can truly echo the sentiments of two of my favorite groups, the O'Jays, *"I love music!"*, and Earth, Wind and Fire, *"When you feel down and out, sing a song, it'll make your day!"* Yes, an uplifting song can change the course of your day! Not only can a song affect you individually; it can culturally and universally inspire. In the height of the civil rights movement (a dark spot in American history), James Brown wrote a song entitled, "I'm Black and I'm Proud", that ignited a spark of pride in African American history and undoubtedly unified the African American race, both young and old. Raised fists signifying "Black Power" were displayed paying homage to the African American culture, birthing promises of "I

Have a Dream" outlooks for a brighter day ahead. This moment in time validates that there is power in a song!

3. **Poetry**: This was my first tool of expression as a child; it was the channel that unleashed the hurt and pain that was bottled up on the inside! At first, my poetry was dark and destructive because that is how I felt inside. I wrote about heartache, violence, and dying. Now that I have discovered my worth, I use my poetry to exhort and encourage others. I still write with emotion; however, I am no longer crippled with suicidal and destructive imaginations; instead, I am walking tall on the stilts of positive self-esteem and confidence.

4. **Life-learned lessons**: Whoever penned the quotation, ***"Experience is the best teacher"***, spoke volumes! "Father Been There" and "Mother Done That" have definitely been my constant school masters. I have also gleaned so much insight from those who had foreknowledge of where I was headed (or as the Bible so eloquently declared-- "those who overcame by "the words of their testimonies"), who imparted revelation so that I would not make the same mistakes. Throughout the book, I will reflect back to my hometown, Sugar Land, Texas, located about 20 miles due south of Houston, where I was born and raised until my senior year in high school (a life-changing experience). Sugar Land is where it all began, the geographical origin of my low self-esteem.

Some of you may be interested in what prompted me to write this book about women and our self-esteem. Well, a few years ago, I began to take inventory of my life and reflected back to moments of pain and disparity. Inquisitively, I reminisced of past events and probable factors which may have shaped or affected my choices and decision-making process, especially in relationships with the opposite sex. Being a two-time divorcee, I pondered whether there was something in my genetic makeup or my cultural upbringing that caused me to get involved with the type of men I have been involved with and why I accepted their immoral behavior. Furthermore, I began to wonder if there were some unresolved issues and factors from my past

that led to the breakup of my two marriages. I analyzed why certain men found me attractive and in retrospect, why I was drawn to them. Humorously, I thought that maybe there was a particular scent or signal that I sent out that said, "Hey, she has vulnerabilities and insecurities –go get her!" My time of reflection led me back to my childhood and the negative self-image I had of myself. I explored five important questions concerning my low self-esteem:

- **What**-- caused it?
- **When**– did it begin?
- **Where**-- did it originate?
- **Who**-- invoked this behavior in me?
- **How**-- can I break free from it?

As a lurking shadow, this gloomy image of despondency followed me into my adulthood, but somehow I learned to mask and camouflage it--so I thought anyway. Externally, I used my pearly white smile, and what a pretty smile I have; yet internally, I was crying out. I lied to myself and other, pretending that I was a whole and happy person, when I was really fragmented and broken. My greatest mask was Christianity! Yes, I could really hide behind that mask because I did not have to pretend alone; there were others who were pretending with me within the congregation. All we had to do was sing a few hymns, and quote a few Bible verses then no one would ever know that we were scared puppies - afraid to face our fears and insecurities. Besides, if I pretended that I was "holy" and "righteous" then I could justify my lack of esteem by labeling it with so-called humbling statements (generically used in some churches) such as *"I am just a sinner saved by Grace!".* (I know that we were once sinners but after our conversion, the Bible refers to us as "new creatures". We should have acquired a name by now – Paul is no longer Saul –new name, new nature!) How about, *"I am just a wretch undone!"* (I took the liberty to look up the word "wretch" and it means "poor devil" or "someone you feel sorry for". Any association with the devil cannot be positive.) Another classic one, *"We are but filthy rags in God's eyesight!"* Being compared to a "filthy rag" left confusion in my mind but I later discovered that the Bible refers

figuratively to our righteousness as "filthy rags" and not the person (Isaiah 64:6). So, what do you do when the music stops, the tambourine stops tinkling, and you can no longer hear today's sermon ringing in your ear? Have you ever been in a crowded room; yet, you felt so all alone? How do you cope with the loneliness, the isolation, the depression, and the pain of low self-esteem?

Well ladies, I do not profess to have all the answers to these questions, but I can say that when I decided to do as the soulful singer and American Idol winner, Fantasia, so boldly gave us permission to do, *"Go ahead and free yourself"*, I discovered that I do not have to hold on to the ghosts of my past, nor do I have to stay bound to those who do not enhance my life. I learned how to mentally free myself, even when I could not physically remove myself from it. I discerned how to regurgitate negative words that were sent to destroy me and digest positive declarations and affirmations, such as *"I am beautiful in the eyesight of God!" "He created me for a purpose, and He is well-pleased with me!" "I am loved by many and hated by few!"* In other words, I will constantly and consistently speak words that will accent my life, and not detract from it.

As you read this book, I hope you will also find tools to free yourself from whatever form of low self-esteem has you bound. If this condition does not apply to you, then read this book and use it as a reference or study guide so that you can help other sisters overcome the dragon of low self-esteem. Prepare yourself for the journey!

# THE DRAGON

# THE RED DRAGON
## (The Spiritual Journey)

**Revelation 12:1-5**

*1) And there appeared a great wonder in heaven; a woman clothed with the sun and the moon under her feet, and upon her head a crown of twelve stars:*

*2) And she being with child cried, travailing in birth, and pained to be delivered.*

*3) And there appeared another wonder in heaven; and behold a great <u>red dragon</u>, having seven heads and ten horns, and seven crowns upon his heads.*

*4) And his tail drew the third part of the stars of heaven, and did cast them to the earth: and <u>the dragon</u> stood before the woman which was ready to be delivered, for to devour her child as soon as it was born.*

*5) And she brought forth a man child, who was to rule all nations....*

Let me take you on a journey! This is no ordinary journey because, as the text above clearly states, the place of origin is heaven. To continue this journey you have to put on your spiritual goggles, because natural eyes cannot see, nor can a natural mind comprehend "heavenly" occurrences. You are about to experience a "great wonder" more spectacular than

1

the "Seven Wonders of the World", and more defined than "Mount Rushmore"; an event so unique and impossible to duplicate. I want you to know that this journey occurred **BEFORE** your earthly existence--before your descent on earth. Jeremiah 1:5, states, *"Before I formed you in the womb I knew [and] approved of you [as My chosen instrument], and before you were born I separated and set you apart, consecrating you* **[Amplified Bible]**.

Imagine this "great wonder"- a majestic, impeccably beautiful and radiant woman, impregnated with the seed of promise: a stately and fashionable woman, dressed in garments tailor-made for her. Her skin is as smooth as butter and as flawless as silk; pregnancy adds a glow that illuminates her rapidly-changing physique. She is wearing a bright red robe, beaming with "possibilities", wrapped in glory, adorned with "the brightness of His Coming" (angelically anointed), and clothed with the sun. Subsequently, Webster's Dictionary describes the sun as a life-giving force that is "critical for our existence", positioned in the center of the universe. Metaphorically, a woman's womb is positioned in the center of the body, and is the life giving force that is critical for the existence of "the seed". There is nourishment in the womb; there is safety and protection in the womb. Furthermore, the woman's womb acts as the "control tower" that orchestrates the flight plan in the birthing process.

In this biblical account, this "great" woman is stepping on the moon (sometimes described as the lesser light). Each step signifies her God-given authority, authenticating that God has put everything under her feet (See Psalm 8:6). The moon is the catalyst to the dawning of a new day -- rich with hope, overflowing with opportunity, with limitless choices and potential. With the moon, she sends forth a memorandum to the darkness that even in the "night time" - through life's darkest moments--there is light at the end of the tunnel (defined as a "potential barrier")! The moon offers encouragement that if you hold on and faint not; in a short while, the sun shall rise again, breaking the cycle of

darkness, and ushering in the morning; which symbolizes new beginnings and fresh starts. As a footnote, this was the role of Lucifer (The Son of the Morning) when he resided in Heaven--to usher in the start of a new day, until he was fired and kicked out of Heaven. Now, he has turned into a dragon-like beast, full of rage, jealousy, and anger that spits poisonous venom and strikes out at anyone that he deems a threat – especially those who have discovered their worth and are overflowing with promise.

Throughout her pregnancy, the woman has nurtured the promise, felt it leap in her belly on numerous occasions, and watched her body expand to make room for the promise. The seed has grown to its fullest potential. It is no longer a seed or an embryo (**a thought or an idea**); it has matured and developed into a full-fledged baby (**manifested vision**). It is now a recognizable entity with distinguishing parts of its own – eyes to see the vision; a nose to breathe life into it; a mouth to proclaim the vision; fingers to raise high to honor and glorify it; and feet to carry it forward. No longer can it be confined, or boxed into a small enclosure; it now needs room to expand and survive on its own. It is time for the baby to be separated from the very womb which nourished it, and kept it safe. There is no longer purpose in the womb--the time of delivery is at hand. Ladies, have you ever noticed the skin of a baby who has stayed in the womb too long? The skin is wrinkled and dry, because there is not enough water (representation of the Spirit) to sustain it in the womb. The brook has dried up – procrastination and stagnation only hinders progression--time to move forward and discover new territories. Isaiah 54:2 says it best, *"Enlarge the place of your tent, stretch your tent curtains wide, do not hold back."* You should have some "stretch marks" by now!

Because of the size of the vision, it is causing some pain and discomfort for the woman. She can no longer sleep on the vision; she restlessly turns from side-to-side. She is uncomfortable; yet, excited at the same time, because she knows that her delivery date is rapidly approaching. Then, the water breaks and the contractions begin... signifying

that it is indeed time to deliver that which was promised from the beginning. Each step of the way, the pain intensifies, and she dilates centimeter- by-centimeter (line-upon- line, precept- upon-precept), giving space to the vision.

Now, the baby is firmly set in the birthing chamber; the woman is ready to push. Oh no, there is something blocking the entrance to the birthing chamber! What is it? It's a red dragon. The red dragon is also described as a **wonder;** but not a **great wonder;** he is limited in his power because he lacks the ability to do the one thing that a woman was designed exclusively to do – give birth! Therefore, he could NEVER deliver the promise; he has no vision. The Bible clearly tells us **"Where there is no vision, the people perish"** (Psalm 29:18). And, greater is He that is living on the inside of you than He that is in the world! That is why the dragon is so mad at you, ladies! You have purpose! The sad thing about it is that most women do not realized just how valuable we are and the impact that we make on this entire world.

Who and what is this dragon, and what is his purpose? Well, let us examine him a little closer. One of the dragon's primary purposes is to deter or delay the vision. I call it **The Theory of Delay**. The breakdown of the word (dragon) alone signifies delay, **drag – on**. You see, the dragon cannot STOP your process or your destiny, he can only try to delay it or **drag**-it-**on**. Furthermore, the root word **"drag"** is defined in Webster's on-line dictionary as *"something that retards motion, action, or advancement"*, which further supports my **Theory of Delay**. The purpose of these situations is to stunt your growth and to delay/retard your advancement. When I was a child, we used the word "retarded" to describe someone who was "mentally-challenged" or incapable of functioning according to the "norm". Enough said!

The second purpose of the dragon is to force you off course (to run you off the road) in order to change your direction,

4

so that you will lose focus of your destiny.  I call this **The Theory of Distraction**.  Dictionary.com describes the root word "*drag*" as *"force into some kind of situation, condition, or course of action"*.  This clearly supports my perception of "the dragon of low self-esteem" because it distracts you from your intended purpose, and forces you into situations and conditions that you would not accept under normal circumstances.  I am sure all of us have had those "I can't believe I did that!" moments.  Some of these situations appeared to be good, but later you discovered that it was not good for you!  These are the dragon's missions: 1) To mentally incapacitate you; 2) To impair your vision; and 3) To distract you and to devalue your worth.

You see, this dragon has heard about your assignment, and he is well aware that you have been chosen for greatness.  How does he know?  Job, Chapter 1, verses 6 and 7 tells us:

*Now there was a day when the sons of God came to present themselves before the LORD, and Satan came also among them.*

*And the LORD said unto Satan, "Whence comest thou?" Then Satan answered the LORD, and said, "From going to and fro in the earth, and from walking up and down in it."*

1 Peter, Chapter 5, verse 8 further quantifies, "*Be sober, be vigilant; because your adversary the devil, as a roaring lion, walketh about, seeking whom he may devour*."

Interestingly, these scriptures clearly emphasize that our adversary is **walking** to and fro!  Therefore, it is presumptuous that the adversary has legs, and if there are legs, we can also presume that there is a body lurking around – observing!  So, the devil is **not** a beast-like creature (so to speak) walking around with a pitch fork.  He

5

comes in human form—like you and I. He could be operating in an associate, a co-worker, or even a loved one, to distract you from your Divine purpose.

Furthermore, the dragon positions himself in key places where the "Sons of God" congregate (sounds as if he is in the church to me – and since the church is predominately occupied by women – it is safe to also presume that he spends a great deal of time around women!). He knows how to transform himself into an angel of light, and he knows how to make wrong appear right! Like a lizard or a chameleon, he knows how to blend into the crowd, making it difficult for even some of the "elect" (hand-picked, selected ones) to discern his presence. Many have been conned by his "smooth talk"; he can eloquently quote the scriptures. Like the Pied Piper, he has lured many followers off-course and has driven them to a dark, cold, bottomless pit, without hope of turning. He wants you to miss your day of visitation--your hour of ascension --your moment of maturation, in order to prohibit the fulfillment of your assignment. Do not let him!

Now, some of you are probably wondering where this low self-esteem originated? I am glad you asked! Let us refer back to Revelation 12:4. The scripture illustrates the dragon as having seven heads. You see, the dragon **never** travels unaccompanied; he brings his "posse" with him - much like wolf packs. In fact, he has a kingdom established with officers on every level in every capacity. (The Bible refers to them as "principalities".) He dispenses his officers according to the level of your assignment, considering the impact and threat you have on tearing down his kingdom. If the **dragon of fear** is dispersed, chances are the **dragons of doubt, discouragement, depression, frustration,** and similar dragons are also dispersed along with him. These "gang" members spontaneously attack your immune system, leaving you with low-iron deficiency (low self-esteem).

Have you ever been given a group assignment and had someone on your team who opposed or spoke negatively

6

about every idea that was presented (the **demon of doubt**)? You said, "Let's have a bake sale!" She interjected, "Sugar attracts ants!" You said, "Let's go bowling!" She replied, "Most of the people in the group have bad backs so it is not a good idea!" Every action brought an adverse reaction. Did not that frustrate you? (The **demon of doubt** summoned the **demon of frustration**.) In your frustration, you became discouraged because the road to victory seemed so far away. (The demon of frustration brought forth the **demon of discouragement**.) Before you knew it, the entire group had been affected, time had been wasted, and you were far behind schedule! And, so the cycle of destruction began...!

The dragon and his beasts know that "timing" is everything and there is a "window of opportunity" allotted to complete each assignment. Habbakuk 2:3 states, *"For the vision is yet for an appointed time"*, and it further states *"it will not tarry"*! So, the dragon tries to devour your promise before it is manifested, because once the vision is birthed, he knows that his time is short. It is his mission to cause an abortion or a still birth. Still births make me sad! Imagine a mother, who has nurtured and carried a baby inside, felt it kick, watched it grow, and then discovered, prior to birth, that the baby is dead. More perplexing is that sometimes when a still birth occurs, the doctor induces labor to simulate the real birthing process. The mother has to endure the pains of childbirth, even though the baby is already dead. The dragon's mission is to cause your vision to be still born. That is why low self-esteem is one of his greatest tools. The dragon is well aware, that if you know your worth, he cannot contaminate or play with your mind. The scriptures declare, "As a man thinketh, so is he!" Low self-esteem makes you devalue your "greatness". If you think you are defeated; you **are** defeated! If you think you cannot accomplish the mission; then you **will** fail! If you think you are ugly, then you **will** feel and act ugly! When I was a teenager, I would peer up into the mirror with my head bowed. Peeping up at my reflection, I would tell myself that I was ugly, and I **TRULY** believed that I was ugly. I even walked with my head down. I remember when

7

I was in junior high school, my boyfriend, Michael, repeatedly told me, "Look up, you're going to run into someone with your head down!" But that is where my self-esteem was--on the ground.

A few weeks ago, while cleaning out my storage room, I found one of my high school prom pictures. Since my perception of myself has changed--that picture looked drastically different to me. In fact, I realized that I was actually "cute" and the negative perception that I had drawn of myself all those years was completely **FALSE**. Incidentally, that is one of the characteristics of the dragon – **falsity** - he is such a liar. As a matter of fact, he is the "father of lies". He has sold many of us "wolf cookies" far too long, which is the exact reason he was able to deceive a third of the angels (*the third part of the stars of heaven*). His deceitfulness filled the angels' heads with false promises, hopes, and dreams that he was unable to deliver, and led them on a course of destruction, causing them to fall rapidly into hell (a place of hopelessness and despair). Ladies, do you remember your first love and your first heartbreak? Remember the disappointment and disillusionment you felt? So, you could imagine how these angels felt when they found out that the promises Lucifer made to them were just lies, causing them to lose their position in Heaven. What a costly price to pay! Therefore, it is important that we know our purpose and our worth so that we will not be swayed off-course by a "Lying Lover".

The good news is that the dragon could not stop the great woman from fulfilling her destiny. In spite of all the dragon's efforts, Revelation 12:5 clearly pronounced, *"And she brought forth a man child..."* At the appointed time, she gave birth to her baby and overcame **EVERY** obstacle that the dragon put in front of her. Depression could not obstruct her manifestation! Loneliness could not block her evolution! Rejection could not hinder her advancement! Fear could not cloud her perception! Low self-esteem could not detain her promotion! The "great wonder" had singleness of vision; her eyes were fixed on the finish line! She realized that she had come too far to turn

back!   "There is NO stopping her now!" ***Push Sister Push!  Push Sister Push!  P-P-P-U-U-U-S-S-S-H-H-!  Birth – That – Baby!   Produce The Promise!***

And it came to pass...

*"And there was war in heaven: Michael and his angels fought against the dragon; and the dragon fought and his angels, and prevailed not; neither was their place found any more in heaven. And the great dragon was cast out, that old serpent, called the Devil, and Satan, which deceiveth the whole world: he was cast out into the earth, and his angels were cast out with him". [Revelation 12:7-9]*

And now the journey begins on earth.....!

# DRAGON PERSONALITIES

While researching the different personality traits that shape our lives, I found a very informative on-line newsletter article entitled, *Dragon Personalities*, posted by the Institute of Management Excellence. Each trait highlights characteristics that can be directly-related to the probable cause of low self-esteem, which is defined as the "Dragon of Self-Deprecation". This entire chapter is derived from the book, *Transforming Your Dragons: Turning Personality Fear Patterns into Personal Power*, by Jose Stevens. I hope you find it enlightening; I did!

Dragons are personality traits that act as challenges to overcome in achieving our life's purpose. Almost everyone has one dragon; many of us have more than one.

Personality Dragons represent the obstacles on our path in getting to the end of our Game. The "dragon" name originates from ancient myths and stories, where there is always a dragon that must be slain before we can reach our goal.

**_Self-Destruction_**. This is the tendency to harm oneself either physically or emotionally out of the belief that life is not worth living. Self-destruction affects about 10% of the US population.

**_Greed_**. Greed is a desire for more and more of something (for example: money, love, food, experiences). Greed affects about 15% of the US population.

***Self-Deprecation***. This is a sense of unworthiness/low self-esteem. They often apologize first or put themselves down. Self-Deprecation affects about 10% of the US population.

***Arrogance***. Arrogance is a false sense of superiority, often covering intense feelings of low self-esteem. Arrogance affects about 15% of the US population.

***Martyrdom***. This is the sense of being victimized; they create suffering for themselves. Martyrdom affects about 15% of the US population.

***Impatience***. Impatient people constantly rush from one thing to another — missing out on where they are. Impatience affects about 15% of the US population.

***Stubbornness***. Stubborn people do not want to change or let go of their position or viewpoint. Stubbornness affects about 20% of the US population.

- Dragons have the ability to integrate themselves so tightly into a person that they become invisible to the person — as in fairy tales.

- Dragons disguise themselves as beautiful friends, changing shape as they transform themselves to stay hidden.

- Dragons are extremely powerful and cunningly deceptive in their ability to "pretend" to be something good for us or to pretend that we have eliminated them from our personality.

Remember, the Dragons are part of our challenge to overcome in the Game of Life. They extend the Game and keep us playing. They play a big part in helping us walk into unpleasant situations without seeing them coming.

For people with two Dragons, sometimes only one is operating at a time. At other times, both may be operating. For example, a person may be Arrogantly Stubborn, or Stubbornly Martyred.

### ✳ The Greed Dragon

People with the Greed dragon may take things that are not theirs; take advantage of other people to gain things they don't really need; or are constantly striving for "more", even though they seem to have plenty already. In severe forms, people with greed may steal or hoard things to such a degree, that they call attention to themselves. A person with the Greed dragon will never feel happy or fulfilled, no matter how much they have.

### ✳ The Impatience Dragon

People with the Impatience dragon may have huge "to do" lists that never get finished. They spend so much time rushing around that they fail to spend enough time on what is important. They don't listen well and don't remember things. People with impatience will usually show signs of restlessness (pacing, drumming their fingers, chewing their fingernails) that can be very annoying to others. Taking time to rest and relax is very difficult for them.

### ✳ The Arrogant Dragon

Children with arrogance grow up being compared to impossible people or

standards. Parents constantly judge the child and criticize them harshly for not being perfect. As adults, they carry serious self-doubts about their worthiness. Often, they strive for perfection to prove that they are really OK, so that they will not be criticized again.

 ## The Stubbornness Dragon

 People with this dragon will have difficulty adjusting to changes, especially those that are sudden. They may resist anyone else's opinions. Pushing them to move more quickly will only harden their determination and resistance. The stubbornness dragon must be melted and softened; it cannot be attacked head on.

## The Self-Deprecation Dragon

People with this dragon may not try things that they are actually capable of doing, or plead incompetence when asked to do something, believing they cannot succeed. Often, they hold their head down, avoiding strong eye contact. They slump their body, which restricts their ability to breathe deeply. They will avoid anything that calls attention to themselves, and apologize for themselves and anything they do. Children with self-deprecation grow up without praise or rewards, and a very negative expectation of their ability to achieve or be successful. This is reinforced by their own failures and they learn to withdraw from life.

## ✳ The Martyrdom Dragon

 People with this dragon constantly complain and whine about whatever is going on. They always find someone else to blame for anything they perceive is wrong. No matter what efforts others make to help them and make them feel better, the person with martyrdom is unhappy and unappreciative. Other people start to avoid them because they are so unpleasant to be around. As adults, the person grows up feeling they must be good, but they suppress their own rage and hatred, because they feel they are not worthy of expressing their true feelings. They create a life for themselves that looks like they are victims. They will not and cannot allow anyone to help. Their friends leave them and they fulfill their fear of abandonment. People with martyrdom will defeat any attempts to help them. They often have physical problems because of the physical stress on their bodies.

## ✳ The Self-Destruction Dragon

People with this dragon may have little regard for the property and safety of others, or they may act in ways that are destructive only to themselves. The Self-Destruction dragon in people who are immature or psychologically unstable, can lead to serious violence in the workplace or in their community. Outer demonstrations of the Self-Destruction dragon are noticeable recklessness. Internal manifestations may be quiet desperation and a sense of futility. Some grow up to act out violence or destruction against other people or against society in retaliation for

their bad treatment as children.  In the extreme, they are suicidal and eventually destroy their own life.

The best ways to slay the dragons are:

1. Become aware of them.
2. Acknowledge that they are keeping us from getting what we want from life.
3. Learn their symptoms and how they affect our lives, our health and our relationships.
4. Learn how they appear to others.
5. Ask our friends and other supporters to help us get them under control.
6. Learn how to lessen the stress in our life that feeds the dragons.
7. Actively take part in slaying our personality dragons. [1]

# KNOW YOUR WORTH!

# THE EVOLUTION OF ME!
## (Overcoming My Identity Crisis!)

*I am a woman of purpose-my destiny is clear and my navigation is on-course...this ship is going somewhere! Vickie L. Evans*

When I was in my 20's and 30's, I heard women in their 40's state that "life gets better after 40". At that time, I mentally brushed them off and said annoyingly under my breath, "Yeah Right!" Now that I am a card-carrying member of the 40's (almost 50) club, I can truly say that life really DOES get better after 40. I know most women hate revealing their age; however, for the sake of making this point, I will! After 46 years of being a conformist, I discovered "the real me" and what makes "me" happy. For so many years, I battled through an "identity crisis", self-manufactured to please others, some of who were not deserving of my time! The "me" I discovered was wrapped in layers of negative thoughts, images, and interpretations. These negative connotations were transmitted from failed relationships, rejections by family and friends, bouts of depression, anxiety, and unfulfilled dreams that invoked massive and destructive dosages of low self-esteem.

After the breakup of my second marriage, I sought the counsel of a very powerful pastor, preacher, and prophetess named **Pastor Cordelia Wallace.** I met and heard Pastor Wallace minister at a women's conference, in Washington DC, at Bishop Greg Porter's church, Cathedral of Light. During the time that our paths intertwined, I was feeling despondent and heartbroken because my husband of one year had abandoned me. Several years later, once again feeling hurt and despondent, after reconciling with my husband, and receiving his second and final decision to leave, I called Pastor Wallace at her residence seeking her guidance and advice. **After crying my eyes out about my**

17

losses and setbacks, she asked me a set of very important questions. What do you want to do for you? What makes you happy? Do you like yourself? Honestly, I did not know the answers to these simplistic yet probing questions. I did not have my own exclusive identity. My church, employment, and social activities were interdependent on my family. Simply put, I was a follower--bound by fetters and chains, embellished by those who appeared to have my best interest at heart, whose true identities were camouflaged.

From an early age, my thoughts were encompassed with desires of marriage, having children, achieving a certain social status, living in a certain neighborhood with my family, and so on. I never solely considered what would make me a whole and happy person separate from anyone else. I married in my late teens, started a family in my late teens, and became consumed with the triad roles of wife, mother, and church member (each which were of equal importance).

Without notification, I experienced the "interruption of everything" that I revered as vital to me. My children were grown--living their own lives, and making their own decisions (the empty nest syndrome). My marriage was over the second time around and I was left with a hole in my chest larger than the Grand Canyon. What was a forty-something woman to do? Although I was entering the stage of life when I thought I would be settling down; instead, I was faced with starting something new! I never imagined life without a man living with or sleeping next to me. I feared being alone and now my greatest fear had come to fruition.

If you would allow me, I would like to digress a moment and speak on the triad roles that were so important to me— marriage, motherhood, and religion. Most of my life has been spent trying to please others—defined as "approval addition". *The pressure of conformity can often mislead and misguide us into taking courses of actions that were not specifically designed for our*

18

*destinies.* Oftentimes, we embark on journeys that are off-course, unproductive, destructive, and out of sequence with the blueprint that God had predestine for us--while we were yet in our mother's womb. As I stated, the expectation was instilled in me to grow up and find a "good" man, and be a "good" wife, at an early age. Then, I was expected to produce "good" children, for that "good" man, so that we could be a "good" family. I lived my whole adolescent and teen life with that *Leave It to Beaver* image lodged in my mind; although the family images around me were less than perfect (domestic violence, infidelity, etc.). However, the invisible achievement bar was raised higher for me. The implied expectation was to have a better life and marriage; however, no instructions or roadmaps were given in how to make that mandate a reality.

Religion was another factor that contributed to my illusive idea of the model family image. Church mothers adorned in long-sleeved, ankle-length dresses (even in the summer), accessorized with matching hats that could double as fruit baskets, deposited messages of "submissiveness" and "submergence" (I call it the weaker vessel syndrome), which conjured up images of women being subservient or subordinate to their men (as the prefix "sub" implies by virtual definition). Linked with the "sub" messages, was the proverbial sexual reminder that it is "better to marry than to burn". The thought of burning eternally in hell, due to a misguided sexual fantasy, scared me to death and quickly set me on a course to find a husband, before I "bust hell wide open" (smile). Seriously, not once did anyone encourage me to love myself first and then I could love another, nor did anyone ask the proverbial question Pastor Wallace asked, "What do **you** want?"

And then there was the marriage thing! The significance of being single, happy, and whole was overshadowed by the misnomers of "your time clock is ticking" or "being an "old maid", if you were not married by a certain time. Therefore, some women (myself included) rushed, settled, and were sucked into relationships that were not suitable or compatible just to escape that dreadful label. The taboos of

being over thirty, single, and childless were societal ills that I did not desire to tackle, nor did I want to face the stigma of being alone.  Now, here I stand, two husbands later, facing my greatest fear--being alone.  Speaking for many divorcees, this was a place that I never envisioned.  How would I manage?  Frankly, I had never been completely alone nor have I ever had a place of my own.  I acclimated from living in my mother's home to living with my husband; I never had the responsibility of meeting my own financial obligations – until now!  Little did I know that my whole destiny was about to change and that my greatest fear was about to become my greatest asset.  **Unbeknown to me, this butterfly was about to emerge out of her cocoon to experience the "best years of her life".**

Ladies, as I previously stated, it took me 46 years to begin de-programming, downloading, and dispelling from myself all the obstacles and misperceptions that prevented me from unleashing the "real me".  I am three years into my restructuring and I have learned some valuable lessons during my time of transition; I call it from crucifixion (the death of my flesh – the old me) to resurrection (spiritual rebirth – the real me).

Insightfully, I changed my perception of being alone.  I learned that in Christ I am NEVER alone.  My relationship with my Savior became so personal that it amazed me!  **My former pastor, the late Georgianna Smith, constantly told me, "Get to know God for yourself!"**  Prior to my emancipation, I believed that I truly knew God in a very personal way; however, on this wonderful journey called "life", I discovered that there are deeper levels of knowing Him, and I was about to enter into a realm of Agape love that I had never experienced.  When I was younger, I sang a song in church– *Every Day With Jesus Is Sweeter Than The Day Before*.  Little did I know that I was about to discover that this was not just a song; but, a testament.  Truly, I can say that every day brings new discoveries – I hunger for more knowledge of Him.  Jo Ann Rosario summed it up nicely in her song, "*More! More! More!*", as did Jonathan Butler when he testified that *"Falling In Love*

*With Jesus, Was The Best Thing I Ever Done!"* I never understood the definition of true intimacy until I fell in love with Christ. I discovered that He cares so much for me and that He becomes all things to me at all times; He is the Great I Am. In the times when I did not know where and how I was going to meet my obligations (I lost my job for four months, foreclosure dangling over my head); He came through right on time as **JEHOVAH JIREH** – My Provider! When doubt and discouragement ganged up on me and tried to convince me that I was insufficient, inadequate, and incapable; He revealed Himself as **EL SHADDAI** - My Sufficient One! When loneliness and depression boldly stood up in my face and made me cry out in desperation because of isolation and loneliness; He let me know that He is **JEHOVAH-SHAMMAH**, He is always there. That is why my confidence is in HIM--my husbandman! I have never had ANYONE to love me as much as He loves me. Loving Him has brought out an air of assurance and self-confidence in me that causes me to soar to limitless heights. That is how I am able to write books and pour out my soul. In contrast, I was very introverted and shy (another word for fearful) until I discovered my worth, and realized that I do not have to live my life ashamed of my past. Romans 8:1 says, "***There is therefore now no condemnation to them which are in Christ Jesus, who walk not after the flesh, but after the Spirit***". Ladies, I have been set free!

Secondly, I learned the proverbial meaning of **"walking by faith and not by sight"**. There were times when I could not see my way out of a paper bag – but I survived through blind faith. There are still times when the bills supersede the finances, but I persevere, and He always has a "ram in the bush". I am the first to admit that yes, I have experienced some financial, emotional, spiritual, sexual, and lack of intimacy challenges; however, God has kept me sane. I have faith that He has good things enstore for me and that He will give me the desires of my heart. I have faith in Him in the selection of my mate; He has tempered my sexual urges (I did not think this was possible, but the more I walk out my purpose by helping others, the less I

21

concentrate on my own affections.).  I have gained patience
through my celibacy; believe me, celibacy is a great teacher
of patience!   He stabilized my financial imbalances – I have
suffered periods of unemployment and times were tough;
yet, He has been my constant Source.  Did I mention that I
went from renting a townhouse for $950 a month to
purchasing a house with a mortgage of $1900 a month,
without a substantial increase in my salary?  I have lost
some material things as the result of my divorces, but I have
gained much more than I lost--spiritually and mentally—
irreplaceable things that can never be lost to include: peace
of mind; love for myself; love for others; joy unspeakable;
freedom to make choices; and a hope for tomorrow.   I am a
survivor!

Finally, I witnessed the evolution of me and undeniably--I
know who I am, whose I am, and how valuable I am. Yes, I
am an entrepreneur—I know how to make something out of
nothing!  I am a published author; I am sharing my life-
learned lessons and serving as a witness to countless people
globally!  I am a playwright; my first professional play
opened to a sell-out crowd, without additional financial
backing or corporate sponsorship.  I am a minister; I am a
servant of the Most High and my mission is to aid in saving
souls, being a mouthpiece for God, telling people that they
can be saved and live freely without condemnation.  I am a
mother; I have carried, nurtured, and empowered two male
seeds of Abraham and a daughter of Zion--royal priesthoods
and heirs to the promise.  Each day of my life I am seeking
how I can birth spiritual sons and daughters in order to
leave a legacy so that the Kingdom of God can be fruitful
and multiply.  I come from great parentage; royal blood
runs through my veins. My Father is the greatest and most
powerful Father in the whole world—-"**I Am**" is His Name.
I am a virtuous woman; my price is far above rubies (See
Proverbs 31).  *I am a woman of purpose--my destiny
is clear and my navigation is on-course...this ship
is going somewhere*!

Ladies, I HAVE EVOLVED!  Do you know your worth?   If
you do not know your purpose and your worth, you will

allow the 3 "Ds" (disappointment, discouragement, and depression) to reign in your life, and you are destined to repeat the perils of your past. There was a point in my life, (my late-twenties) when I was searching for direction and answers. During that time, I felt that I had lost my dreams, my being, and my self-esteem. Oh, what a "confusing" time! During my reflection, I reverted back to my childhood when I utilized poetry as a means of expression. It (my time of reflection) prompted me to write this poem which I would like to share with you, entitled, "Reflections":

### REFLECTIONS

*Today I took a moment to look inside of me;*
*to ask unanswered questions; to reflect on what I*
*see.*

*As I looked within my soul, my mirror of*
*complexity,*
*I asked: what is the cause of my vulnerabilities?*

*Is it because I've had my share of life's inequities?*
*Or, because I search for perfection instead of*
*impurities?*

*Is it because I feel hollow and so alone?*
*Even though I tell myself - "Girl, you can make it*
*on your own!"*

*What causes my insecurities? Why do I blame*
*myself?*
*Am I the cause of my miseries, or is it someone*
*else?*

*Am I just too serious? Should I just relax and let go?*
*Should I take life as it comes and let the rhythm flow?*

*Should I be more patient? Stop worrying and let things be?*
*Should I stop letting others pull my strings and let my love run free?*

*As I take this time to reflect on what I should and should not be,*
*I realize that where I end is strictly up to me!*

*Even though the road ahead, I cannot fully see,*
*I realize the Lord above controls my destiny.*
*Lord, I surrender my will to Thee!*

I pray that before you arrive at the end of this book, you will reflect and affirm, "Yes, I know my worth and I am right on course with my Divine destiny." Let us journey on...!

## CONFIDENCE VERSUS CONCEIT
## (Which Are You?)

*"Humility is just a tool or buffer to provide balance and stability so that confidence does not escalate into conceit." – Vickie L. Evans*

I have a friend who walks as if she is walking on Cloud Nine, or as if she is striding down a modeling runway! Her head is erect, her shoulders are back, and she gently sways her hips, as if a melodious tune is playing in the background to mark her entrance. When she walks into a room, it appears as if all eyes are focused on her as she glides with an air of assurance. My friend does not make a special effort to walk in this manner; it comes naturally and is a part of her makeup. She has confidence!

*I believe that confidence validates the fact that you are "fearfully and wonderfully made" (Psalm 139:14) and that your essence and presence is significant in any given situation.*

Maya Angelou said it best in her poem "Phenomenal Woman" :

*"It's the fire in my eyes,*
*And the flash of my teeth,*
*The swing in my waist,*
*And the joy in my feet.*
*I'm a woman*
*Phenomenally,*
*Phenomenal woman,*
*That's me."*

On the other hand, **conceit** is defined as **"**excessive appreciation of one's own worth or virtue"[2], or simply

25

having too much confidence. Oftentimes, individuals, who are full of conceit, prey on those who lack confidence like vultures. They are opportunists and seek occasions to promote their own agenda, at the expense of others. Their over-glamorization or over-inflation of their lives gives others the false impression that they are much more than they really are. And we all know that over indulgence can lend to adverse reactions (i.e., too much fat intake causes obesity; too much alcohol intake leads to intoxication; too much drugs ingestion leads to addiction--you get my point?) Therefore, too much confidence (conceit) leads to overbearance, obnoxiousness, eccentricity, and the utter disregard of other's value or worth. Ladies, there is a fine line between confidence and conceit. Therefore, it is imperative to know the difference so that you know with whom and what you are dealing.

Many times an air of confidence is confused with an attitude of aggression; some people believe that it is impossible to be confident and humble at the same time. Sometimes I wonder if that is the reason why some women find it hard to accept compliments. After a Sunday service, I complimented a minister on her great words of exhortation, after the delivery of a powerful sermon, and she responded, "It wasn't me; all glory goes to God"! I thought to myself, "I should hope so, seeing that she openly proclaimed to be a minister of the Gospel. Even with her opening statement she said, "Giving honor to God", and in retrospect, the principles and foundation of her sermon were Biblically-based. I am not knocking the acknowledgement of God as her Revelator, but sometimes I believe that there are occasions when stating the obvious is unnecessary. What is wrong with simply saying "thank you" in acknowledgement of the fact that God granted you the authority to be his mouthpiece – to give honor and credence to His existence? Saying "thank you" does not indicate that you are robbing God of His Glory nor does it imply that you lack humility. Simplistically, it demonstrates that you confidently accept the fact that you have been "chosen" and assigned the task to eloquently deliver the Good News. Philippians 1:14

states, *"And many of the brethren in the Lord, waxing confident by my bonds, are much more bold to speak the word without fear."* I believe that God has given us all unique attributes and characteristics that we should utilize and embrace, with confidence. It is high time that we acknowledge our worth and declare that *"We are nothing less than royal diadems, adorned with the finest tapestry, embellished with the most precious stones (jasper, rubies, diamonds, sapphire, topaz—you name it)."* (See Isaiah 62:3)

I deem it as **"false humility"** when people think or express words that indicate that they are less than God created them to be. Showing confidence does not mean that you lack humility. *Humility is just a tool or buffer to provide balance and stability so that confidence does not escalate into conceit.* Conceit, now that is "a horse of a different color". Several synonyms come to mind when defining conceit such as arrogance, "self-glorification", "uppity", "snobbish", and "obnoxious".

One of my favorite movies which illustrate conceit is *Devil's Advocate*, starring Al Pacino and Keanu Reeves. It is about a successful Floridian prosecuting attorney named Kevin Lomax (Reeves) who had tried and won all (64) of his court cases. Kevin is offered a high paying job by a prominent law firm in New York owned by John Milton (Pacino). Kevin's wife, Mary Ann, portrayed by Charlize Theron, is an ambitious and exuberant real estate agent who sought validation of her worth through the flamboyancy of her husband. Her behavior only added "fuel to the fire" to his arrogance and conceit. When the couple moved to New York, Mary Ann's low self-esteem was exposed due to the fact that she no longer had a high-profile career, and Kevin's ambition and long evenings at the office began to distance him from her. In fact, he began to view and treat Mary Ann as a nuisance.

Greed and arrogance (conceit) eventually led to the downfall of the once-loving and prestigious couple. The

more power, position, and promotion Kevin Lomax received, the more callous, shallow, insensitive, and unloving he became to Mary Ann. Anyway, John Milton (Pacino) immediately recognized Mary Ann's lack of esteem coupled with Kevin's conceit and used them as tools to destroy their lives. Subsequently, the wedge between Kevin and Mary Ann widened deeper than the hole in the Grand Canyon, sending her in a deep, dark state of depression. Feeling disdain, Kevin had Mary Ann committed to a mental institution where she eventually committed suicide by slitting her throat with a piece of broken glass. ***The dragon of conceit controls, suffocates, derogates, and eventually destroys an individual with self-esteem issues.***

At the end of the movie, John Milton's true identity was revealed as "The Devil", and Kevin was informed by his sanctimonious mother that he actually was John Milton's son – his heir and successor. Metaphorically, I view conceit as an heir of the devil, also. John had one daughter as well; and he needed Kevin and his sister to procreate so that his evil bloodline would remain pure.

When Kevin realized that Milton advocated the evil acts that led to Mary Ann's death, he confronted him and pointed an accusatory finger at him. One of the most memorable lines, spoken by Pacino's character was, "I am not directly responsible for Mary Ann's death; you are! I only used what was already in you!" The devil's final statement in the movie was equally profound: "Vanity...definitely my favorite sin!"

In order to break free of the victimization of individuals loaded with conceit, you have to learn to recognize the signs. You have to confidently and assuredly know that you are just as important and valuable as anyone on this earth and no one can devalue you in any manner.

Here are my personal observations of conceit:

1.  **Conceited individuals believe that their accomplishments are far above everyone else and no one can meet, beat, or rise up to their level of expectations.** They devalue everyone else's worth, and try to make you feel like gum under their shoes. I had a co-worker who thought she was America's most fashionable dresser. Every day, she talked about what other co-workers were wearing by referring to it as "a hot mess". Everyone's outfit was a "hot mess"-- including mine. One "Friday Dress-Down Day", I wore a pair of jeans which had asymmetrical squares on them (which happened to be in style). She asked me if I was auditioning for a 1970's movie entitled, *Cleopatra Jones*, and of course I was a "hot mess". A month later, she wore similar jeans with asymmetrical squares and I reminded her of our prior discussion. She stated that her jeans were not the same as mine, and that they were stylish designer jeans (Donna Karan or something). I tell you, those jeans were so similar that it would take close examination under a microscope or magnifying glass to find the difference in squares. However, when I wore it, it was a "hot mess"; yet, when she wore it-- it was "designer fashion". She always found a way to devalue others' self-worth while boosting up hers.

2.  **Conceited individuals deflect their guilt or blame on others; they never find themselves alone in a fault.** On another occasion a network security officer came by our section and told this same co-worker mentioned above that she had downloaded software on her PC that was incompatible with the office's standard and instructed her to remove it. She told the officer, "Vickie downloaded some software on her PC, why isn't she on your list?" The officer replied, "Maybe her software is compatible because she is not on my

list!" Although her finger pointing attempt failed; her initial thought was that if she was going down, someone else was going down with her. *Conceited people are incapable of accepting responsibility for their own actions; they are like crabs in a barrel, always pulling others down to prevent them from ascending to the top of the barrel before them.* They are quick to point out your character flaws while elevating their own accomplishments.

3. **Satan (The Dragon) is the Master of Conceit:** Satan tried to use trickery and deception to elevate himself into places reserved for God and his angels. Ezekiel 28:2 says, *"Son of man, say unto the prince of Tyrus, Thus saith the Lord GOD; Because thine heart is lifted up, and thou hast said, I am a God, I sit in the seat of God, in the midst of the seas; yet thou art a man, and not God, though thou set thine heart as the heart of God"*. Ezekiel 28:15 further adds, *"Thou wast perfect in thy ways from the day that thou wast created, till iniquity was found in thee."* Iniquity is simply described as "going beyond reasonable limitations" or "committing an unrighteous or immoral act". Simply, he began to think that he could do and be better than God. Therefore, he sealed his plight of being expelled from Heaven; along with a third of the angels (Misery loves company.). Conceit equals defeat!

In conclusion, confidence is a positive affirmation that signifies that-- *I know my worth, I am balanced, and I am not trying to be more than I am, nor do I lower my standards*. I declare and acknowledge that "I am the head, not the tail; I am above, not beneath". Steady is my pace--I do not live above my means, nor do I live beneath it. I further highlight that it is acceptable to walk in step with Christ with acknowledgement of the wonderful gifts and talents that he has placed within me. I recognize

that "it is not robbery to be equal with God" (See Philippians 2:6); however, I stay within my boundaries to ensure that I do not get ahead of Him.

In contrast, conceit is the over-emphasis of one's worth and the denial (in thoughts and actions) that God has anything to do with one's accomplishments. It is also the warped notion that implies that "I am a self-made woman", and that no one is a factor in my success.

*A woman who knows her worth is centered, disciplined, and personifies an "air" of confidence that will not allow pessimism or life's curve balls to rob her of her self worth, nor will it lower her self-esteem.* Integrity is her foundation--which yields the fruits of modesty, humility, wisdom, peacefulness, determination, responsibility and stability. She is not a "gossiper" nor is she double-minded.   She is a great friend to have in your corner; she celebrates your sisterhood and is genuinely excited when you succeed. Exhortation and praises are her strong suites; she does not seek her own recognition, but is heralded by others. "Her price is far above rubies" (See *Proverbs 31:10b)* and she wears the garments of grace, adoration, prosperity, and glamour. You cannot put a price tag on her worth --it is innumerable and immeasurable. Respectfully, I take my hat off to all my confident sisters who know their worth-- you got it going on!

## OPTIMISM VERSUS PESSIMISM
### (Attitude Matters)

Have you heard the story of the two shoe salesmen who were dropped off via helicopter on a tropical island to sell shoes to the natives? After encountering the natives, the salesmen found out that they walked around barefoot and did not have any shoes. The pessimistic salesman called the shoe headquarters and told the dispatcher to send the helicopter back to pick him up because there was no need for shoes on this island, "The natives are comfortable barefoot!" On the other hand, the optimistic salesman called back and told the dispatcher to fill the helicopter with shoes, because the island was a shoe salesman's paradise, "Everybody needs shoes!" In reality, this is how our life experiences are; it is all in how you see it!

The optimist will somehow find a ray of hope in the worst situations. No matter how bleak or dim the situation appears; they will light a candle and make it brighter. In stark contrast, the pessimist will blow out the candle and poor water on it so that it will never light again. She (the pessimist) will magnify the problem making it appear worse than it actually is, while the optimist will magnify the solution and show the light at the end of the tunnel!

A perfect illustration of the difference between optimistic and pessimistic individuals is the biblical account found in Numbers, Chapters 13 and 14, concerning the twelve spies that Moses sent to spy out the land of Canaan (The Promise Land). Canaan was described as a fruitful place with enormous grapes hanging off the vine; a land flowing with milk and honey. When the time arrived for the spies to make their report before Moses and the children of Israel, the spies brought samples of the fruit found in Canaan, which included grapes, pomegranates, and figs. Unanimously, the twelve spies agreed that the land was

flowing with milk and honey; however, ten of the spies (the pessimists) focused on the inhabitants of the land (the problem) instead of the abundance of fruit (the promised blessings). The pessimists focused on the son on Anaks, who were giants, and feared them because they were carnivorous (people eaters). Furthermore, the pessimists viewed themselves as "grasshoppers in their (the Anaks) sights" and cowered like scared puppies, who were afraid of their own shadows.

Here are some typical characteristics of a pessimist:

- **Pessimists magnify and over-inflate the complexity of their problems.** A pussycat is seen as a mountain lion; they make "a mound out of a molehill". Pessimists are afraid to take a challenge head on. They like to remain in the status quo—even if the status quo is broken. They could be right on the edge of a "break though" but because of their own insecurities, they remain in the same situation.

- **The pessimists minimize their worth and have no confidence in their own strengths or abilities.** The ten spies described themselves as "grasshoppers" in the giants' sight. They (the pessimists) felt small, inadequate, defenseless, and incapable of possessing the Promise land. Yet, they were the same group of people who witnessed the destruction of Pharaoh and the entire Egyptian army in the Red Sea; these are the same people who were fed fresh manna from heaven on a daily basis; and the same people whose clothes lasted for forty years without being worn out. However, here they stand on the brink of inheriting that which was promised--suffering amnesia – forgetting their testimonies of deliverance; failing to reflect on the battles that had already been fought and won!

- **Pessimists usually travel in flocks and gain strength in numbers.** In this case, it was ten

pessimistic spies versus two optimists. I will be willing to bet that not one of them mentioned their views to Joshua or Caleb **PRIOR** to the scheduled meeting with their "commander-in-chief", Moses. They remained silent and waited to air their grievances before an audience.

- **Pessimists' constant companions are fear and doubt, and they subsequently transfer their fears to others – creating a global atmosphere of pessimism.** Fear has a way of paralyzing you— making you forget from whence you came and bad news travels faster than a Boeing 747. A rumor in the hands of a gossiper is more dangerous than TNT in the hands of an arsonist. It will spread fear and doubt faster than the poisonous venom of a snake. Listening to the pessimists prohibited the majority of the children of Israel from reaching the Promise Land. In fact, only the two optimists, Joshua and Caleb, were able to enter in and obtain the Promise.

How would you like the state of your future determine by pessimists? Put yourself in the Israelites position for a moment, you have taken a 40-year journey; you are at the brink of having your dreams fulfilled (so close you can taste it); and here come the doubters to deter you from receiving what you worked so hard to accomplish! In some cases, majority rule is not the best rule.

Now, on the other end of the spectrum, we have the optimists like– Joshua and Caleb, who are primarily few in numbers. In most cases, there is always a remnant of individuals that stand strong in the midst of adversity. Here are a few characteristics of optimists:

- **Optimists focus on the goal, not the obstacles or distractions.** Joshua and Caleb saw the fruit and not the loot. They were not distracted by the giants (the

34

sons of Anak) because they had evidence and countless testimonies to prove that He that made the Promise was greater. They realized that the God who brought them across the Red Sea and delivered them out of the hands of Pharaoh; could surely overthrow some giants. Notice that the first mention of giants was initiated by the pessimists.

- **Optimists move with haste and not with waste; they are ready for action.** Caleb commanded, "Let us go up at once and possess it." In other words, we do not have time to waste on such negativism and foolish talk. Optimists are ready and willing to face challenges head on. They are naturally born "fighters".

- **Optimists are risk-takers; they do not walk in fear.** Joshua and Caleb knew their worth and had great confidence in their ability to possess the land. They were not fearful. Caleb stated, "We are well able to overcome it! They did not deny the existence of giants; yet, they were confident in their ability to defeat the giants and any other challenge.

Ladies, *attitude matters*! How you see your life, is how you live your life and vice-versa; how you live your life, is how you see your life! Is your glass half empty or is it half full? With an optimistic attitude – you win! With a pessimistic attitude – you lose! While surfing the internet, I found this very applicable expression entitled, "Attitude Matters" which makes distinct contrasts between a winner and a loser. It reads:

*The Winner is always part of the answer;*
*The Loser is always part of the problem.*

*The Winner always has a program;*
*The Loser always has an excuse.*

*The Winner says, "Let me do it for you";*

*The Loser says, "That is not my job."*

*The Winner sees an answer for every problem;*
*The Loser sees a problem for every answer.*

*The Winner says, "It may be difficult but it is*
*possible";*
*The Loser says, "It may be possible but it is too*
*difficult."*

*When a Winner makes a mistake, he says, "I was*
*wrong";*
*When a Loser makes a mistake, he says, "It wasn't*
*my fault."*

*A Winner makes commitments;*
*A Loser makes promises.*

*Winners have dreams;*
*Losers have schemes.*

*Winners say, "I must do something";*
*Losers say, "Something must be done."*

*Winners are a part of the team;*
*Losers are apart from the team.*

*Winners see the gain;*
*Losers see the pain.*

*Winners see possibilities;*
*Losers see problems.*

*Winners believe in win-win;*
*Losers believe for them to win someone has to lose.*

*Winners see the potential;*
*Losers see the past.*

*Winners are like a thermostat;*

*Losers are like thermometers.*

*Winners choose what they say;*
*Losers say what they choose.*

*Winners use hard arguments but soft words;*
*Losers use soft arguments but hard words.*

*Winners stand firm on values but compromise on petty things;*
*Losers stand firm on petty things but compromise on values.*

*Winners follow the philosophy of empathy:*
*"Don't do to others what you would not want them to do to you";*
*Losers follow the philosophy, "Do it to others before they do it to you."*

*Winners make it happen;*
*Losers let it happen.*

*Winners plan and prepare to win.*

Ladies, in order to overcome the dragon of low self-esteem, you have to form positive relationships and correlations and expel negative influences and abominations. Live your life with finesse and not with regrets. Life is a journey--choose your roads carefully!

## MORNING COFFEE
## (The Stress Reliever)

*"Good to the last drop!" Maxwell House*

Most mornings, on my commute to work, I call my friend
Brenda to share conversation. Brenda and I both have our
own specialized ministries, so we usually have much to talk
about, or we just talk about life in general. Sometimes I just
call her to vent and get things off my chest. At any rate, our
morning talks give me energy and add a spark to my day.
Oftentimes, I use her words of wisdom to keep me on the
right course so that the distractions and misguided
conversations that I encounter, throughout the day, do not
take their toll on me. I like to refer to our "chats" as
**morning coffee**.

I am not a regular coffee drinker, however; I am surrounded
by people (my mother and stepfather included) who will not
start their day without a cup of coffee. Just look around at
the number of people charging to Starbucks™ or the
neighborhood 7 Eleven™ stores for that cup of "Joe". The
National Coffee Association found "in 2000 that 54% of the
adult population of the United States drinks coffee daily
(NCA Coffee Drinking Trends Survey, 2000)". [3] During my
research, I found some enlightening discoveries concerning
the benefits of drinking coffee. "Coffee reduces diabetes
risk among pre-diabetics by over 60%, according to a new
study from the University of California at San Diego. Some
exciting work is showing how coffee may help reduce the
risk of a number of diseases and ailments, including type 2
diabetes, Parkinson's, colon cancer, cirrhosis, gall stones,
depression, and more." [4]

So you see, there is great significance in "morning coffee".
That is why I enjoy my talks with Brenda because
synonymously our talks have great benefits for me, as well.

Our talks relieve my stress, alleviate depression, provide positive reinforcements, and more importantly, build my self-esteem. Sisters, everyone needs someone who can act as a stimulus or buffer for their life. If you keep your frustrations bottled up on the inside of you--you are sure to develop some type of ulcer or psychological condition (such as stress or depression) that will adversely affect your mind, body, and soul. I affirm the quote, "Confession is good for the soul". James 5:16 states, *"Confess your faults one to another, and pray one for another, that ye may be healed.* It is interesting that this scripture uses the word "healed". Have you ever been so "sick and tired" that you were "sick" and "tired"? I have been so mentally drained until the only thing I could do was go home and get in my bed. Stress has a way of weighing on you so heavily that it zaps your energy and affects your health. It is my opinion that some of the physical ailments that we contract--such as cancer, hypertension, heart conditions, and definitely ulcer--are in direct correlation with the stress that we inflict upon our lives. I have already given you statistics that says that natural "coffee" can benefit your health; well, I am declaring and decreeing that spiritually "morning coffee" can benefit your health, as well. That heavy load that you are carrying – find a trustworthy friend with whom you can release your heavy burden. Erykah Badu wrote a very appropriate song entitled, "Bag Lady" that says:

*Bag lady you gone hurt your back*
*Dragging all them bags like that*
*I guess nobody ever told you*
*All you must hold on to*
*Is you, is you, is you*

*One day all them bags gone get in your way*
*So pack light...* [5]

Ladies, "You are too blessed to be stressed!" Release the beast. Let go of the dragon of self-deprecation. "Lay aside the weight that you are dragging around before your hurt yourself. Think on all of the wonderful accomplishments that have been bestowed upon you, and there is more to

come!  The next time you are on your way to work, call up a friend and enjoy a freshly-brewed cup of morning coffee.  It will add pizzazz to your day.  Relax, and enjoy the journey...!

## I ONLY EAT FILET MIGNON!
## (Simply the Best!)

I was born and lived most of my teenage years in the great and fabulous state of Texas. Although notable for many things-one being America's greatest football team, the Dallas Cowboys (which I am an eternal fan), one of our greatest staples is our Texas beef. As you know, there are many varieties of beef. You have the T-bone, the prime rib, the Porterhouse, and, of course, the filet mignon. There is nothing like a plump, juicy cut of steak, smothered with onions, mushrooms, and gravy, complimented with a fully-loaded baked potato with sour cream, cheddar and chives, and a tossed salad with ranch or blue cheese dressing. Ladies, do you remember a time when you ordered a steak, but when you took a bite; it was "tough"? There is nothing worse than "tough steak"!

Some of us have eaten some "tough steak" in our lives. These experiences were extremely hard to digest and gave many of us "heartburn". The dragon of low-esteem launched a plan of attack against us, while we were children, causing mental "rape" (to seize and force your mind into a state of worthlessness), through situations beyond your control. You were violated, victimized, abused, misused, degraded, broken, defiled, and infringed upon, by people whom you trusted. Some of you were violated by "mentally deranged" family members, who crossed the line and broke the family covenant. Some of you were affected by poor relationship choices of a "loved one" (a "sexually sick" boyfriend or stepfather). Some of you were products of your environments (underprivileged, drug ridden, and "gang banging" neighborhoods), and were manipulated and forced to make undesirable choices, for survival sake. Others have dealt with brutal domestic violence! Several are still carrying the residues of rejection by a parent or loved one! Many are still mourning the death of a loved one (a husband, a parent, a sibling, or a child)! A few are still

41

shook up from childhood "growing pains"! Countless have been mistreated or ridiculed because of physical appearance (obesity, anorexia, inappropriate labels of unattractiveness)! A portion has experienced marital infidelity and divorce! *"**Whatever the case, it has been "tough steak; which inadvertently has caused some deeply embedded scars and wounds that formed thick, callous layers of mistrust. You have erected walls of defense that are very difficult to penetrate**.*

Due to these challenges, many have been robbed of their childhood innocence, forcing them to grow up at an accelerated rate. Some have even been robbed of one of the most precious gifts that a woman exclusively possesses – her virginity, which caused some women to "detest" men; producing an overwhelming influx of lesbianism! Simply stated, some have been robbed of their joy. The purpose of the attack was to place your mind in a "gutter state" to prevent you from knowing, achieving, or receiving life's prosperity (which I define as simply—the best). Unfortunately, I do not have any easy solutions to these difficult and heart-wrenching problems. However, I can say this...if you will take the steps to find a place of solace and healing, you will discover that filet mignon is available to you! Why fillet mignon? **The fillet is considered to be the most tender cut of beef, and one of the most expensive."[6]**

One of the characteristics of filet mignon is that "**the muscle is non-weight bearing ....**"[7] I am reminded of *Hebrews 12:1b* that requests, "..... *let us **lay aside every weight**, and the sin which doth so easily beset us, and let us run with patience the race that is set before us* (**NIV**). The word "beset" in this scripture is defined as "to attack from all sides; to trouble persistently; harass; to hem in". [8] How many of you can relate to feeling hemmed in or enduring multiple and simultaneous attacks? That is why it is so important to purge or leave the baggage on the curb. The automobile manufacturer, Chevrolet, has a commercial

showing the singer, Mary J. Blige, driving around with a carload of "Marys" from different stages of her life, as displayed on her various albums.  During the commercial, she pulls over, takes the baggage from the rear, and leaves them on the curb.  The announcer makes a profound statement at the end of the commercial; he states, *"The space to take everything with you / **The wisdom to leave the baggage behind.**"*  This statement is in correlation with one of my favorite songs, "The Gambler", by Kenny Rogers.  The lyrics say, *"You have to know when to hold them; know when to fold them."*  Ladies, I cannot stress this enough, there are some people, situations, and things that you must have the wisdom to simply let go--rid yourself of the weight!  A marathon runner's pace is impeded when she runs with weights.  An airplane has more difficulty soaring to a higher altitude when it is overloaded with baggage.  "Laying aside the weight" opens the door to forgiving!  Forgiving others is the best method to alleviate weights.

So many of us are still carrying around yesterday's troubles!  Not only are we carrying yesterday's troubles, —we are carrying last week's, last month's, last year's, and some years past.  Sisters, you have to "lay aside the weight" by any means necessary (counseling, therapy, support groups, praying, etc.).  "Laying aside the weight" will help you to treat others with kindness, even when kindness is not being returned unto you!  "Laying aside the weight" will assist you in releasing the grudge that you have been carrying against that person that violated you!  "Laying aside the weight" will change your thought pattern to digest "the good" and regurgitate "the bad"!  "Laying aside the weight" allows you to eat filet mignon – the best and the most expensive commodities life has to offer you.  You will be free to live freely!  You will be free to breathe freely!  You will be free to give freely!  You will be free to eat filet mignon freely!  Why?  Because you are worth it!  No more ground chuck for you!  No more settling for less; you are the best!  Tell that situation that has held you captive for years, "**I only eat filet mignon!**"  Tell that person who has unlawful

possession of you mind, **"I only eat filet mignon!"**
Encourage yourself and loudly declare and proclaim, **"I only eat filet mignon!"** As the *Wendy's* fast food chain
commercial asked, "Where's the beef?" Answer the
question, "Here's the beef – and I am priceless! The next
time you visit your favorite steak restaurant, instruct the
waitress to bring you a fat, juicy, mouth-watering, tender
cut of filet mignon! Then, sit down with your napkin
around your neck, and eat up, because, you are simply the
best! Another of my favorite singers, the ageless Tina
Turner, re-made a song a few years ago that said, ***"You're simply the best, better than all the rest! Better than anyone, anyone I've ever met!"*** Tell yourself, I
am simply the best, and yes, I deserve filet mignon! I
encourage you to live your best life because even greater
things are enstore for you! Tell your neighbor, "I only eat
filet mignon!" Digest it....make the most of the journey!

## IT'S JUST A MATTER OF FACT!
## (Stuff Just Happens!)

Ladies, why is it that when certain events or circumstances that parallel in retrospect with our lives; we see it as a sign or an omen from God? Do you realize that some things and occurrences "just happen"? These things are not necessarily designed exclusively for our lives; it could just be a global/universal occurrence that could of, or would have happened to anyone, at any given time; you just happened to cross paths with it on that particular day. For example, when a seed is planted it has a predetermined time to bring forth fruit. The predetermined time may coincidentally fall on your birthday; yet, there is no Einstein scientific method, or supernatural correlation, nor are there extenuating circumstances, except the mere date, that connects your birthday and the emergence of the seed. Some of us are "too deep" and "super spiritual", especially when it deals with matters of the heart.

Many men are fleeing from churches at enormous speed, because some "super sanctimonious" woman has prophesied (rather prophe-lied) and predicted that he IS to be her husband/soul mate. I speak on this matter because I have been an abuser of this injustice also-- not so very long ago. Therefore, I can speak on it from a fresh perspective. I recently became re-acquainted with a friend, at our 30-year class reunion, who I had a crush on in high school. I took our reconnection as my second chance to re-ignite a spark that I desired years prior. The fact that the both of us were "divorced" really elevated my level of excitement and gave hope to my "theory of unification". Surely, this must be a sign that we were destined to be together. It did not enter my mind that at least 150 fellow class alumni were tied to our reconnection; yet, my focus was exclusively on him! Unfortunately, he did not "get the memo", nor did the fuel of my "secret" passion re-ignite his flame (or should I say ignite because I learned that he did not know that I had a

crush on him during our high school days), neither did we visualize the re-crossing of our paths in the same manner. I saw infinity (a lifetime); he saw finite (a date)! I saw star-lit evenings, candle-lit dinners, and romantic strolls in the park. He saw a ride to the event, celebrating the evening, and a kiss goodnight (I had my one moment of fulfilling a fantasy.). Yes, we did share some time alone –catching up on lost time. Yet, that is all it was – a special night with an old friend, reminiscing about old times. I, on the other hand, was stuck in a time period, so very long ago, that I could never recapture, re-live, or re-create! Some things are just a matter-of-circumstances and a matter-of-fact. It is a part of our history! The fact remains that he and I will always be knitted together in the aspect of graduating from the same high school, in the same city, in the same year, on the same date. Fact is that our reunions will occur on the same day, on the same year, along with approximately 300 other seniors who graduated from our high school in that year. The fact remains that our marital status or the lack there of caused us to be classified as "divorced" at the same time. All of these facts are not omens that imply that we are destined to be together. Do I still have feelings for him? I certainly do! But truth be told, those feelings are based on the image that I created some thirty odd years ago. Feelings, that he did not share then, nor does he currently have! Feelings, that he had no prior knowledge. Besides, much has changed in thirty years; we are not the same people that we were then. Teddy Pendergrass penned a song entitled *Love TKO*, which says, *"I think we better let it go, looks like another love TKO."* Sometimes it is better to "drop out" before you get "knocked out"!

There are too many of us holding on to "what should of", "could of", or "might have been". Sometimes, it is better to enjoy the wonderful memories that originated from that relationship (fact or fiction) and just close the book and realize that on occasion –"Stuff just happens!" Face the reality of the journey and move on!

# OVERCOMING

# WHOSE LABEL ARE YOU WEARING?
## (Overcoming Stereotypes)

*"If the underlying requirement for me to form an association or build a relationship is for me to lose my identity--in order to fall in line with someone else's drum beat; I choose to remain off-beat and alone!"* - **Vickie L. Evans**

In this 21st century, health-consciousness has become an important factor.  Great emphasis is placed on caloric intake and counting, daily exercising, and maintaining low carbohydrate diets.  As a result, label-reading has become a regular occurrence.  Labels tell you what is on the inside – it distinguishes the corn from the peas.  Undoubtedly, the significance of labels is undeniable; how would you know what you are purchasing if it did not have a label?  Without the label, all canned goods are universal and look alike – a plain, insignificant, indistinguishable, silver, aluminum tin can.

However, what would happen if the wrong label was applied to the can?  Imagine opening a can expecting green beans, but instead it contains okra?  Or, opening a can expecting sweet potatoes, but it has sauerkraut?  Certainly, that would not be a good experience.  Sadly enough, there are many people walking around unhappy and unfulfilled because someone has wrongfully categorized them or marked them with the wrong labels.  My former pastor, Bishop Eugene Reeves, shared with our congregation his childhood experience of how he was labeled as a slow- or challenged-learner in grade school and how the teachers/counselors said that he would never be able to obtain a "normal" education.  But thanks to a Sunday school teacher, who declared that he "could do all things through Christ", a spark of confidence was ignited within him to excel beyond his imposed limitations.  Not only did he receive a normal

education, he surpassed it by obtaining an Associate of Applied Science in Computer Science, a Bachelor of Arts in Biblical Studies, a Bachelor of Science in Business Administration, a Masters of Arts in Counseling, and a Masters and Doctorate of Divinity. This just goes to show you that not all labels are accurate. Thankfully, positive affirmations can effectuate a swift transition, re-align you with your intended purpose, and put you back on track with your destiny.

Labels also provide details of the amount of a specific ingredient that is inside the can, such as the sodium or fat content, which I define as the **character** that gives the main ingredient flavor. A very wise man, Dr. Martin Luther King, Jr., once had a dream that his children would not be *"judged by the color of their skin but the content of their character"*. Therefore, knowing the right content is very important! I wrote a poem that echoes Dr. King's saying entitled, "Don't Judge Me"!

*Don't judge me by the color of my skin*
*But judge me by the character I have within*

*Don't judge me by my cultural dialect*
*But judge me by my insight and intellect.*

*Don't judge me by my physical attributes*
*But judge me by my charitable contributes.*

*Please don't label me incorrectly!*
*Spend a moment to get to know the real me!*

Inappropriately applied labels have caused irrevocable damage in some cases. There is an illustration about an eagle whose egg was mistakenly placed amongst some chicken eggs. The eagle's egg hatched at the same time the chicken's eggs hatched. The eagle lived amongst the chicken, pecking around on the ground for food, eating what the chickens ate, sleeping where the chickens slept,

and clucking like a chicken.  One day a flock of eagles flew over the chicken coop.  The eagle sensed that there was something vaguely familiar about the other eagles; yet, they could fly and he could not.  Subsequently, because he had spent so much time living with the chickens; he was disabled.  Ladies, many of you have been robbed of your self-esteem because you were told that you were a chicken even though you were born an eagle.  You look like an eagle but low self-esteem keeps you in the chicken coop pecking, preventing you from soaring with the eagles.  In order to fly, you have to believe that you can.  R. Kelly wrote a very simple; yet, profound song for Michael "Your Airness" Jordan that declares:

*I believe I Can Fly!*
*I Believe I Can Touch the Sky!*
*I Think About It Every Night And Day!*
*Spread My Wings and Fly Away!*
*I Believe I Can Soar!*
*I See Me Standing At An Open Door!*
*I Believe I Can Fly!"*

If you form associations with those who are content on ground zero and have no ambition to fly, they will hinder your ability to fly, even though you have wings to fly.  Once you are labeled a chicken, people will treat your accordingly.

A few times during my grocery shopping ventures, I found some really good bargains in the "Damaged Goods" bin.  The "Damaged Goods" bin included items that were "marked down" for one particular reason or another.  Some of the canned goods were bent or dented; however, upon taking it home, opening the can, and cooking the contents inside, I found that the dented, marked down items tasted just as good as the regular ones.  A famous quote warns us not to "judge a book by its cover" and the Bible says in Matthew 7:1, *"Do not judge or you will be judged"*.  Too many people have landed in the "Damaged Goods" bin of life due to erroneous judgments and misperceptions based on outer appearance or extenuating circumstances.

In our society, first impressions are usually lasting!  But in some instances, first impressions are not always the right impressions.  Just because you meet someone who is not your "cup of tea", so to speak, does not mean that there is something wrong with the tea; maybe your taste buds are off!  This morning I made myself a cup of tea and put too much sugar in it.  It was the same brand of tea that I always enjoyed, but too much sugar changed it, and made it undesirable to me.   My impression of the tea was based exclusively on my opinion and taste, which also is the basis and foundation of stereotypes – opinions and impressions.  In fact, the website, About.com, defines stereotypes *as "fixed impressions, exaggerated or preconceived ideas about particular social groups, usually based solely on physical appearance."*  This confirms why I detest stereotypes because they are oftentimes inaccurate, biased, and unproductive.

Some typical stereotypes that I have heard concerning African Americans are that we are "lazy"; and that we excel in "athletics" and "dancing" but not in intellect.  Our men are labeled by their sexual prowess using this quote:  "Once you had Black (sexually), you never go back!"  This sounds like an addiction to Crack.  This may not be an offensive statement to some; but it is to me, because it insinuates that our men are guided by their sexuality and nothing else.  Sadly enough, we as African American's also discriminate within our own race – prejudices of light-skinned versus dark-skinned.  Regional and geographic discrimination are also prevalent stereotypes formulating gang activities.  Stereotypes against "Southeast" versus "Northeast" or "East Coast" versus "West Coast" have caused some prominent rap artists to even lose their lives!  These are senseless labels, without validity or merit, which do not amount to a "hill of beans"!

Most stereotypes are based on perceptions and not facts.  One evening, as I was surfing the channels looking for a good movie to watch on TV, I encountered a great movie to

make my point about stereotypes, entitled *Rain*. *Rain* is the film adaptation of a V.C. Andrews book entitled, *Flowers in the Attic*. It is about a bi-racial young lady name *Rain*, who was raised in the inner-city by an all-Black family. After witnessing the murder of her adopted sister by a gang-member, *Rain* (Brooklyn Sudano) was sent to live with her all-White grandmother (Faye Dunaway). Upon Rain's arrival, her grandmother informed her of the "house rules". She told Rain that she knew where she came from (The Ghetto) but in her house, she had certain standards that must be adhered. She informed Rain that she did not permit boys in her house, or the usage of drugs or foul language. Rain's response was, "Just because I was raised in a particular environment doesn't mean that I have done any of the things you suggest. I have never used drugs and my mother brought us up in a respectful manner; she would not allow us to use foul language or to have boys in our house!"

Ladies, using stereotypes to label a person based on their race, economic or social status, educational achievement or the lack thereof, physical appearance, or geographic location is outright unethical. If we could somehow peel off our external label (skin) we would find that we are all the same --just as the outer casing of canned goods; we have the same organs, and the same blood running through our veins. We would also discover that people are people, and if we took the time to get to know one another, we would find that there is something awesome and wonderful about each one of us that could enhance our lives individually, collectively, and globally.

If we would just respect one another and learn how to celebrate our uniqueness, we would discover the beauty in each of us and glean from it. I am an "original by design", distinct from anyone else God created in the universe – with my thick eyebrows, my wide smile, my long legs, my broad hips, and my Southern drawl. I am one-of-a-kind. Even my fingerprints are different; my footprints are distinct; I am a much needed commodity. That is why I have decided

that I will not march by another person's drum beat. *"If the underlying requirement for me to form an association or build a relationship is for me to lose my identity--in order to fall in line with someone else's drum beat; I choose to remain off-beat and alone!"* On the other hand, if I meet someone and we are singing the same tune but our drum beats are slightly off, then by all means I am willing to "tweak my beat" to ensure that we are marching in sequential order with one another so that we can meet on common ground.

Ladies, do not allow stereotypes, or as the Bible make reference, "strongholds", to hold you hostage; pull them down! *"For the weapons of our warfare are not carnal but mighty through God to the pulling down of strongholds"* [2 Corinthians 10:4, KJV]. Strongholds are long-lasting patterns of behavior that are **out of control**. Speak to the strongholds that are hindering your forward motion. Decree and declare that you will not allow stereotypes to control your life. Affirm that you will not give others the power and authority to determine your worth or your value. You have a "specialized identity" – just as your fingerprints are original and exclusive, so are your personal characterizations. There will never be another me –I cannot be duplicated or cloned. When I leave this earth, everything, except my legacy, will exit with me. As Jessie Jackson, president and founder of Operation PUSH, told us to declare some years ago, "I Am Somebody!" I wrote a poem solidifying and validating his message with the same title. Declare it loudly and make it a part of your characterization:

*I Am SOMEBODY,*

*I Won't Be Blocked By Darts Of Negativity*
*Nor Will I Be Tumbled By Daggers Of Hypocrisy*
*But I Will Ascend To The Hilltop Of Unlimited*
*Possibilities*
*As I Climb The Crystal Staircase To My Divine*
*Destiny*

53

*I Am SOMEBODY,*

*I Won't Be Shaken By Life's Tempest Wind*
*Nor The Fiery Darts That My Enemy May Send*
*For My River Of Prosperity Is Around The Bend*
*And You Can Bet Your Last Dollar, In It I'm Gonna*
*Win!*

*I Am SOMEBODY,*

*Don't Sell Me Short Nor Count Me Out*
*Don't Set Traps Of Deceit To Block My Route*
*For I'll Rise Again Without A Doubt*
*High On Eagles Wings, I'll Take My Mount*

*I Am SOMEBODY,*

*I Won't Wallow In The Valley Of Depravity*
*For, I Live By The Law Of Reciprocity*
*Sown My Seeds In The Ground Of Fertility*
*I Will Reap The Benefits Of My Generosity!*

*I  Am SOMEBODY!*

## ARE YOU A TRUE GOLD DIGGER?
## (Winning the King's Heart!)

In the 1980s, a popular song by artist Gwen Guthrie entitled, *Ain't Nothing Going On But The Rent,* became the national anthem for most women, serving notice on their possible suitors that financial stability was a necessary asset for acquisition of a relationship.  One particular phrase served as a calling card to interested men: ***"There is nothing going on but the rent! You have to have a J-O-B, if you want to be with me!*** The hook reverberated, **"*No romance without finance*".**  Perhaps feeling slighted and insulted, the men's response to our call was the negative stereotype "gold digger".   Hip-hop artist Ludacris echoed:  ***"She's dangerous,(Uh huh) super bad. (OK) Better watch out she'll take ya cash. She's a gold... digger."***

Merriam Webster defines a "gold digger" as *a person who uses charm to extract money.*  I have no problem with Webster's definition; however, I do believe that it gives leeway for a broad spectrum of interpretation.  I consider it a misnomer (misusage) and an unconstructive nuance to use the term "gold", a precious metal,  coupled with the word "digger"  to demean and defame women.  Therefore, I created my own definition of gold digger, ***"a highly ambitious woman using strategic means to secure her economic, social, and relational security"***.  Merriam Webster needs to add this to his dictionary.  In this chapter I am on a campaign to change your perception of the term "gold digger".   Let us see if I can tip the scales in my favor.

Let us examine the original gold diggers, the pioneers who were involved in the California Gold Rush of 1849--settlers, miners, ordinary people from every walk of life (some could have been your ancestors) who migrated to California in

search of gold. Why?  1) To seek a better way of life; 2) To improve the livelihood of their families; 3) To rise above poverty; and  4) To obtain the **American Dream**. A-a-a-h-h-h, the **American Dream**! It instructs us to "aim high"; to "believe we can fly"; and to "be ALL that we can be". Yet, when women try to get a "slice of the pie", we are derogatorily labeled as "gold diggers". Can you tell me why? Does not the **American Dream** encourage the acquisition of financial security? What if gold digging promotes your societal status from poverty to middle class or from middle class to upper?

To illustrate my position on gold digging, I will use my hometown, the Mayfield Park section of Sugar Land, Texas, as a point of reference. Our neighborhood was not considered the projects or the ghetto, but I will call it a "blended community". I say blended because everybody knew everyone very well. In fact, most were "kin folks" because of the widespread infidelity. Common law marriages were also a primary part of our culture. I knew a family (married with children) that had the same last names (i.e. both were Davis' but were not related), who swapped mates. Bob and Sue Davis were married and Tom and Linda Davis were married. Well, Bob and Linda began a relationship and moved in together and Tom and Sue moved in together. These families lived directly across the street from the other. So, one set of Davis kids had to go across the street to visit their Dad, and the other set of Davis kids had to go across the street to visit their Dad.

Extra-marital affairs were commonplace in our community. We (the teens) had to be careful about whom we dated because it could be our half-brother, half-sister, aunt, uncle, cousin, or otherwise. Several of the women had more than one "baby daddies", and were content with being on the Welfare system. Many have never traveled outside of Sugar Land and simply settled for this destructive way of life. Sadly, this vicious cycle continued and was passed on from one generation to the next – from their children to their children's children.

Growing up in Sugar Land, I was acquainted with a very beautiful, intelligent, young lady who had two older sisters and one younger sister. All three sisters were, as I described above, (sexual promiscuous with multiple children by multiple men, and on Welfare). Basically, her sisters seemed content with the choices they made. However, this young lady was different – she had ambition, drive, and determination to be someone of great importance. She fashioned herself differently, she had no children, and she behaved in a studious and comely manner. One day, she met a very handsome and "well-to-do" gentleman who immediately took an interest in her. Several months later, they were married and the young lady exited our blended community expeditiously.

Some people, in our little town, referred to her as a "gold digger" and said she only married this handsome gentleman because he had money. So again I inquire, is it gold digging when someone decides to break the cycle of economic deprivation and societal demoralization to find the nearest escape route to a better and more productive life? In seeking a better life, is it wrong to long for the "prince charming" images that this society has long portrayed since our childhood in books like *Cinderella* and movies like Eddie Murphy's *Coming To America,* whose leading ladies were mystically swept away by a "Prince" and a "King" respectively-- whose lives were, as their ending suggested, lived "happily ever after"? Though fairy tales, they instilled in us the premise that we could find a happy and loving relationship with someone special someday. For me, he does not have to possess a crown and a crystal glass slipper, but how about kingdom access, a savings account, an individual retirement account (IRA), and an investment in a house in a safe and stable suburban neighborhood? If dreaming for a better life makes me a gold digger, then I am a true gold digger!

Ladies, in my definition of a gold digger, I mentioned "using strategic means", which simply means that there is an "art"

to gold digging. There are specific skills that must be utilized or traits that must be present in order to successfully be classified as a" true gold digger". One of those traits is beauty. There is no denying beauty has the potential to open doors that, by normal means, would have been closed in your face. Undoubtedly, there are some doors that the gorgeous Halle Berry, the late "voluptuous" Marilyn Monroe, the breathtaking Beyonce Knowles, the stunning Elizabeth Taylor, or the incomparable Ms. Lena Horne have entered into which ordinary people would not have been granted access. To this day, there are some night clubs that pick and choose who can and cannot enter their establishment, based on physical traits. Yes, being beautiful certainly has its advantages and is a beneficial tool for the advancement to positions and places that are normally reserved for the higher echelon. ***Beauty also aids in the acquisition of resources whether monetary or societal, that normally would be unattainable***. If you do not believe me, ask actress Jennifer Lopez or supermodel Tyra Banks concerning the vast number of designers who contact them to promote their products, without cost.

Curiously, how do you define beauty? It is for certain that society's definition of beauty is forever changing. Sometimes "thin is in"! Sometimes it is popular to have "junk in your trunk" (which means having a sizeable derrière)! In the African American culture sometimes "Black Is Back", meaning dark skinned complexion is preferable. Or "Light-skin Is In", referring to a lighter complexion! Whatever the trend, your beauty is determined by "the Beholder" (Society). Therefore, you have **to seize the moment** in order to strategically obtain the title of "true gold digger". Seizing the moment may include developing an extensive beauty regimen. In the Book of Esther, Chapter 2, a twelve-month beauty regimen (purification) was necessary, which consisted of six months with the oil of myrrh, and six months with sweet odors (perfumes) in preparation for the selection of queen. Most men are drawn to women who smell good. Ladies, my point

to this is you have to invest in your beauty. Fix yourself up! Do not let yourself go! ***Your physical attractiveness is the forerunner to a man's desire to pursue a long-lasting relationship with you.*** If you want the best in life, you have to present the best. You have to already look and act like a "queen", if you want to attract a "king". Your investment could strike gold.

Although beauty may be a door opener to position you as a "true" gold digger; beauty without brains/intellect is a useless tool! Let's examine *gold digging* from a Biblical perspective. Truth be told, Queen Esther could be exemplary of "a true gold digger". She clearly fits Webster's definition of a beautiful woman who "used her charm" to win the heart of a rich king. Esther 2:17 reads, *"And the king loved Esther above all the women and she obtained grace and favor in his sight more than all the virgins so that he set the royal crown upon her head and made her queen instead of Vashti.* Queen Vashti, another beautiful woman, lost her position as queen in the kingdom because she did not couple her beauty with wisdom and intellect. When King Xerxes requested that Queen Vashti make a brief appearance to show off her beauty during a gala that he hosted for some very important government officials; she refused. Can you imagine the game show hostess Vanna White refusing to turn over letters for Pat Sajak on *Wheel of Fortune,* which is her key role and function for being on the show? Queen Vashti's rebellion was seen as an embarrassment and disgrace by the king, the government officials, and other guests that attended the party. The consequences of her actions cost her greatly; she was dethroned as queen and used as an example to ensure that the women of that kingdom would not make a mockery of their husbands in such a manner. So you see, just being another pretty face is not enough to be a true gold digger, intellect is a must!

Queen Esther, Queen Vashti's replacement, was not just another pretty face! In fact, she utilized her beauty and intellect to save an entire Jewish nation. In addition to her

external beauty, Queen Esther had confidence, wisdom, grace, knowledge, understanding, virtue, honor, humility, and self-respect – which are all necessary ingredients to be classified as a true gold digger! She had so much beauty and class that later on in the 5th chapter, *after she enticed him with her royal garment*, the king told her to ask for anything she wanted, even half of his kingdom and he would give it to her. She could have asked for the kingdom and "called it a day". Instead, she focused on the "bigger picture" in order to win the entire war (freeing the Jews), instead of winning one battle (sole acquisition of half of the kingdom). Instead, she positioned herself for greatness and accomplished both feats.

Before I continue my campaign, I would like to emphasize that I do not support women whose primary aim is to solely gain riches in a relationship. *A true gold digger does not take advantage of or mistreat her man to get what she wants like Delilah – Samson's wife [Judges 16].* Delilah foolishly tricked her man into revealing that the secret of his strength was in his hair, which she shaved, eventually causing his death. A true gold digger does not set out on a course of destruction to bring a strong man to his weakest point. Proverbs 14:1 states that *"a wise woman builds her house but a foolish woman tears it down"*. Why would you want to bring him down to his lowest point; it is senseless! If he is weak, how can he protect you or how can he provide the treasures that you seek? Your responsibility is to strengthen him where he is weak, so that you both can be complete. It is a "win-win" situation!

However, I am an advocate of a woman knowing her worth and seeking a man who knows his. I do support a woman, who knows that she is more precious than gold, seeking a man who can give her gold. I am for a woman who knows how to please her man and will go out her way to look good, smell good, speak good (kind words), think good (motivational thoughts), feed him good (I am working on that), and love him um-so good! I applaud a woman who

does not mind running his bath water, bringing him his slippers, and stroking his ego a time or two (smile). And if she is a woman worth having, he will go out of his way to shower her with the best of everything. He will seek to make her his queen and offer her half of his kingdom. And because he is worth his weight in gold, she will not mind digging for gold.

Girlfriend, do not suppress or be ashamed of your femininity; use it to your advantage! We are soft and delicate like a rose; see how much beauty a rose brings to the earth? You have the tools; you set the rules!

Here are the attributes of a true gold digger:

1. **Her purpose is acquisition, not devaluation**. She adds value, and she does not subtract from his life! It is the difference between an "Esther" (a wise woman) and a "Delilah" (a foolish woman).

2. **A true gold digger uses strategy, instead of spontaneity, to achieve permanent and long-lasting results.** She does not act on impulse; she does her homework so that she knows exactly what is expected of her. She is accurate; she waits for the right time to approach the king. It is doubtful that the California Gold rushers headed to San Francisco without a map, a compass, or a plan of action. Instead, the successful ones studied and conducted detailed research in order to find the right spot to dig for gold. *Inadequate planning produces inadequate results!*

3. **A "true gold digger" is positioned and commissioned to meet her man's needs AND his desires, as well as her own**. Queen Esther knew that winning the heart of the king was a "win/win" situation. She also recognized that the initial way to the king's heart was through his stomach, so she invited him to a banquet prior to

making her request known. She stroked him in all
the right places! Ladies, if you do not know your
worth, you will accept the "plea bargain" for the gold
plated counterfeit instead of acquiring the real gold.
In relationships, sometimes we settle for second best
(well at least I got a man) instead of waiting and
receiving the king that God has designed especially
for you.

4. **A true gold digger encourages, instead of
   discourages!** She is his number one fan; she
   stands by his side in the midst of adversity. When he
   calls, she delivers! She does not make him ashamed,
   especially in front of great men, as Queen Vashti did
   in this Biblical account. I wrote a poem for my
   mother to present to my stepfather on his 90th
   birthday that sums up how encouragement enhances
   a relationship entitled, "You Are!"

*"I Met You At A Time When I Had Grown
Accustom To Being Alone!*

*But You Convinced Me That In Your Life
Was Where I Belong!*

*We've Grown Together; We've Traveled So
Far
That's Why I Want To Take This Time To Tell
You.... Everything That You Are.......!*

*You Are My High Beam...
You Light Up My Life No Matter How Dim
The Road May Seem!*

*You Are My Greatest Fan...
You Encourage Me And Tell Me "All Things
Are Possible" And "Yes I Can!"*

*You Are My Protector...*

*You Ensure That I Am Safe From All Hurt*
*and Harm.*
*And When Adversity Comes Near, You*
*Sound The Alarm.*

*You Are My Supporter.....*
*You Allow Me To Be Me When Others Don't*
*Understand!*
*When Friends And Loved Ones Walk Away;*
*In My Corner You Still Stand!*

*You Are My Lover...*
*Unselfishly, You Give Of Your Time!*
*You Love Me Unconditionally; With Your*
*Heart, Soul, and Your Mind!*

*I Want To Conclude By Saying You Mean*
*The World To Me!*

*That's Why I'm Prepared To Live With You*
*Forever...Throughout Eternity!"*

So, there you have it, my concept of gold digging. I am indeed a "true" gold digger--what about you? I am worth my weight in gold, I have been tried in the fire; yes, I have withstood the test of time. Now, my sights are set on the golden prize – the entire kingdom! The ordinary just will not do! Why? Because I deserve the best! My king awaits! So ladies, I have commissioned you as honorary members of my "True Gold Digger Club"! Membership is free if you co-sign the terms of agreement to my definition of a "true" gold digger. There is open road ahead of us— there is no stopping us now! Let us change the negative course of the journey...!

# FRIENDLY FIRE—THE STRAY BULLET!
## (Overcoming Betrayal)

*"Yea, mine own familiar friend, in whom I trusted, which did eat of my bread, hath lifted up his heel against me". (Psalm 41:9)*

"Friendly Fire" –a term used to describe death caused by bullets fired from allied or friendly forces, in contrast to "enemy fire". We became acquainted with this term during the Persian Gulf War (a.k.a. Desert Storm) in the early 1990s. Can you imagine being killed by your own friend? Ladies, each of us has a best friend or friends in whom we confide our innermost secrets--someone with whom you can trust and let down your hair! Someone you feel free to call upon at any time, in any given situation. Some of you have friends that are closer than your natural sisters. I have one in particularly who is so much like me that sometimes I think we were Siamese twins secretly separated at birth. We think alike (especially about men), like the same ice cream (Butter Pecan), enjoy some of the same things (except our football teams – I like the Cowboys, she likes the "Deadskins", I mean Redskins), and she is undeniably my greatest supporter and "Number 1 fan" (she will fight you if you try to take that title). I could not imagine doing anything to hurt, harm, or betray her confidence and vice-versa. I have cried on her shoulder during difficult times and she has cried on mine (Come to think of it, I have cried harder than she has.). One of the reason I treasure our friendship so much is because I know how it feels to be betrayed by a friend. If you have not had that experience, it is almost as traumatic as divorce. That is why I can testify to King David's statement above in Psalm 41 and here in Psalm 55:12-13:

*If an enemy were insulting me, I could endure it;*

64

*If a foe were rising against me, I could hide from him.*

*But it is you, one like myself,*
*My companion, my close friend,*

Betrayal by a friend is not a new thing – Julius Caesar was betrayed by his friend Brutus, and of course, the most famous account is of Judas betraying Jesus. Ladies, it is a hurtful situation when you find out that your friend willfully, with malice, and forethought, made an effort to destroy you. Of course, the most damaging weapon of all is the tongue. James 3:8 describes it as **"a restless evil, full of deadly poison".** Lying tongues, gossiping tongues, backbiting tongues, and cursing tongues--breathing out insults, spinning a web of deceit, and sowing seeds of discord! My, my, my, another dirty word – discord. Not only is your friend leading a revolt against you, she has turned others against you. The Scriptures tell us that the Lord **hates** those who sow seeds of discord (confusion) among the brethren. It is like poisonous venom, also! I had a friend, who for no apparent reason, tried to destroy my dream; although she knew how important that dream was to me. The O'Jays said it best in their hit song, *Backstabbers*:

**"They're Smiling In Your Face, All The Times They Want To Take Your Place, They're Backstabbers."**

Backstabbing is the worst type of wound because you do not see it coming nor can you defend yourself against it. The penetration of a knife in the spine is paralyzing – leaving you helpless and lifeless. How could true friends do such a thing?

Most mornings, while preparing for work, I listen to a nationally syndicated radio show to remain connected to global, social, and urban issues, and to hear what is on the mind of my fellow listeners. One particular morning, during the write-in segment, the radio host read a letter

from a very confused lady. The young lady informed us that she had a best friend with whom she had been friends with since grade school. Next, she revealed that she has been sleeping with her best friend's boyfriend for the last six months, and is eight weeks pregnant with his child. Then, she disclosed how her friend is always crying on her shoulder because she suspects that her boyfriend is cheating--not knowing that he is cheating with her! She further revealed that her friend tells her how her boyfriend does not contribute financially; yet, he bought her (the writer of the letter) a brand new truck. Her last shocking revelation was that she and the boyfriend had made an intimate videotape, and she asked the radio host whether she should show this video to her best friend.

By now, you may have formulated your own opinion of the writer of this letter as I did, using such words as trifling, unscrupulous, insensitive, etc.; however, I realized the most fitting description is an individual with low self-esteem. Someone with self-love, self-dignity, confidence, and integrity would not go to such lengths to hurt and backstab another human, and certainly not a friend. In my hit Gospel stage play entitled, *A Change Is Gonna Come*, which depicts domestic violence in church, I wrote this line: ***"I got this thing all figured out; you don't love me, because you don't love yourself!"*** When you have low self-esteem, you have no regard for other people's feelings because you do not have any regard for your own. If you valued yourself, you will not consider the abuse and misuse of your body by a so-called lover, an act of love; however, you will see it for what it really is--lust. A woman who loves herself has restraints and constraints; there are some boundaries that she will not cross. There is no way that I would EVER have a sexual relationship with my best friend's mate, even if they were no longer an item. The fact that he has shared an intimate moment with someone I love and care about would stop me in my tracks; in fact, any attempt by him to seduce me would disgust me. A friend's love is consistent, it does not change. The Bible says, "A friend loves at all times" (Proverbs 17:17). The characteristics of a true friend are honesty, trustworthy, loving, kindness, dedication, with morality and integrity. If

your friend does not display these attributes then is she REALLY your friend?

Ladies, it is high time that we abandon these ruthless and immoral deeds that have infiltrated our sisterhood circle. Let us aim the bullet and slay the dragon of hatred and low self-esteem that is literally trying to destroy our bonds of unity and friendship. Sisters, reclaim your sisterhood! Are you your sisters' keeper? Yes, you are! I would like to leave you with a poem I wrote a few years ago entitled, "Sisters Make the World Go Round".

### *"SISTERS MAKE THE WORLD GO ROUND!"*

*Sisters, What Would I Do Without You And You Without Me?*
*A Shoulder To Lean On, Standing Tall As An Oak Tree?*

*With Our Roots Firmly Planted In God's Word!*
*And Arms Outstretched Proudly To The Heavens Above.*

*A Rock Of Gibraltar In The Midst Of A Storm.*
*Knowing That We Are Safe In The Master's Arm!*

*Sisters, Who Would Dry My Tears When My Heart Break?*
*And Engage In "Girl Talk" Over Ice Cream And Cake?*

*Yes Sisters, We Are The Salt That Add Season To The Land.*
*Divided We Fall, But United We Stand!*

*Through Thick And Thin, We Will Never Depart.*
*That's Why You'll Always Have A Special Place In My Heart.*

Let us unite and finish the journey together!

## HATERADE – THE BITTER DRINK
### (Overcoming Jealousy and Envy)

*"Hate on me, hater*
*Now or later*
*'Cuz I'm gonna do me*
*You'll be mad, baby*
*Go 'head and hate on me, hater*
*'Cuz I'm not afraid of it*
*What I got I paid for"*
*You can hate on me"* [9] - *Jill Scott*

Imagine a cool, refreshing drink of lemonade on a hot, scorching summer day, to quench your thirst! Now, imagine a tall drink of lemonade that looks delicious— garnished with cherries, and a cute little umbrella--but it was made with a tart lemon! No matter how much sugar you add to it, it remains tart and bitter! Oftentimes, that is how hate and jealousy manifest – it arrives in pretty little packages; yet, when you examine the contents, it leaves a bitter taste in your mouth. Looks can be so deceiving. One of the gifts/talents that God has blessed me with is the gift of writing plays. In 2005, I established a talent promotion agency entitled, Soaring High Productions, as a vehicle to give aspiring and novice performing artists, who would not be given the opportunity to display their talents through normal channels, the opportunity to display their gifts/talents on stage. To my surprise, the very ones whom I have assisted and provided an "open door" have been the very ones who have lied on me, scandalized my name (calling me anything and everything but a "child of God"), sought to discredit or defraud me, or attempted to impose measures to cause my failure. The very people who initially patted me on the back are the same people who stabbed me in the back! I can absolutely relate to the scripture that states: *"Out of the same mouth proceedeth blessing*

68

*and cursing. My brethren, these things ought not
so to be. Doth a fountain send forth at the same
place sweet water and bitter?" [James 3:10-11
KJV]*

Haters--anyone of significance has them!  In fact, beware if
you do not!  Whether you are in the "White House" or the
"Big House", you will have haters.  One moment they
proclaim their love and gratitude to you, and the next
moment they try to crucify you.  This should not be a
surprise because Jesus was God in the flesh, and men
reviled and hated him.  The same crowd that praised Him
with "Hosanna", shouted "Crucify" Him approximately a
week later.

Ladies, haters usually cause harm to themselves in the long
run and are usually "hung" by the same noose that they
prepared for you.  A clear example of what happens to
haters is found in the book of Esther, Chapter 9, where
Esther's enemy, Haman, devised a scheme to annihilate
Esther's cousin, Mordecai, and the entire Jewish nation. As
a result, Haman was hung with the same gallows that he
prepared for Mordecai.  Evil renders evil and you reap what
you sow!

*"Hating is the sincerest form of flattery."* [10]
Oftentimes, haters are jealous of you or they are envious of
where you are, and would like to be in your place.  Some of
them may have the same gifts as you; however, they have
neither initiated nor followed through with their giftedness.
In addition, they have not been "anointed" for the season or
reason that you are.  Time, planning, and positioning are
critical factors in achieving success.  The website *Global
Oneness* profoundly defines anointed as follows: *"A true
anointed or christos is one who has achieved the
great victory over self in initiation and therefore
in life, and thus has become a full or complete
adept or mahatma."* [11]  For example, I began writing
plays the same year that Tyler Perry began.  I even recorded
my play on VHS tape then also; however, I was not chosen

to lead the way or open the door of success in stage productions, Tyler was – and opened the door, he has. To further add, I lacked the tenacity and commitment to perform the great task to which he was called. In fact, I quit writing, directing, and producing plays in the late 90s because I could not handle the workload, nor did I want to deal with the performing artists' negative attitudes. Not only that, before Tyler was placed in his mother's womb, he was predestined to be who I deem the "greatest" playwright, director, producer, and over-all businessman that has lived in my lifetime. I cannot be Tyler Perry if I wanted to, even though we share the same gift. There is only one Tyler Perry. I am not going to be him, nor will I "hate on him" because he is the forerunner in this business. In fact, I admire him and intend to take full advantage of the tracks that he has laid down for many playwrights, directors, and producers. In the meantime, I will wait for my appointed time—Habakkuk 2:3 says **"For the revelation awaits an appointed time; it speaks of the end and will not prove false. Though it linger, wait for it; it will certainly come and will not delay [NIV]."** If I patiently wait for my appointed time and refrain from hating; my dream will surely come to fruition! In time, I will see my name in lights, but there is a specific blueprint for me to follow as there was for Tyler. As Paul Masson Vineyards slogan proclaims, **"We will sell no wine before its time"**--my gift will make room for me.

Haters are an integral part of your growth pattern. Ladies, I have come to the realization, that the closer you come to fulfilling your dreams and the further "your gift" takes you; the more intense the hate becomes. Each incidence of hate makes me stronger and wiser. I believe it was Maya Angelou who said in one of her poems, **"The problem I have with haters is that they see my glory, but they don't know my story..."** No thought is given to the work that I have performed or sacrifices that I made to make my dream a reality. I have sacrificed education, socializing, finances (mortgages, and automobile

payments), and vacations to accomplish my dreams. I have certainly paid my dues.

Some days, I wonder how I made it to this point myself! I have had some difficult challenges, and have faced many obstacles; yet, I have managed to stay on course with my dream. At times, doors were closed in my face by friends and foes alike. Even though the hate, jealousy, and rejection that I have received have been painful at times, I would not trade ANYTHING for this journey. As I climb up the ladder of progression, the hating and stone throwing intensifies. I am only on the second rung— four more to go! On one occasion, one of my haters pre-calculated how much money I would make at a particular event, based on my ticket price, and if I sold out at that venue. I was labeled as a fraud with intentions of pocketing the alleged enormous amount of money, and cheating my cast and my staff out of their profits. Instead of receiving profits; I loss money and paid out more than I received. But, according to "the rumor mill", after the event, "I made out like a fat rat!" Haters are like thorns on a rose bud – they attach themselves to success and beauty to prick and inflict pain. They are like a brush fire in a forest spreading rambunctious rumors and sowing tainted seeds of discord. Haters act as if your downfall will produce their windfall. I have yet to understand how my degradation elevates them to a position of success. It makes no sense at all!

I believe that the generator of hate for haters is low self-esteem. Oftentimes, haters are intimidated by someone who shines forth with confidence; they act as "character assassins" in order to mask their own insecurities. As previously mentioned, the dragon of low self-esteem can often be traced back to a childhood action--a negative inflection from a parent, a disabling label from a teacher, a piercing "dig" from a peer—each having long lasting and damaging effects. This seed of rejection is deeply rooted and is transmitted in the form of jealous and envy.

Most people believe that jealousy and envy are the same emotions and use the words interchangeably; however, there are some distinct differences between the two. Envy, which is classified as one of the seven deadly sins, is tri-relational-the hater, the rival, and a particular action or object. For example, a hater could be upset because a co-worker was elevated to a particular position that the rival clearly deserves; but the hater desires. Or, a hater could be upset because her rival purchased a brand new Mars red SL550 Mercedes, the hater's dream car. The hate is generated because a particular action or object. The great philosopher, Aristotle says it best, ***"Envy is pain at the good fortune of others."*** The hater may not hate the rival directly; but, she covets the success she has achieved. Overly-competitive people can be envious. A perfect illustration of envy is the Tonya Harding/Nancy Kerrigan scandal in the 1994 United States Figure Skating Championships (USFSC). These ladies were the top two competitors for that year, and both were previous USFSC winners (Tonya Harding was the winner of the 1991 USFSC and the first American woman to complete a triple axel jump in competition and Nancy Kerrigan was the winner of both 1992 and 1993 USFSC). To ensure her victory by eliminating her competition, Tonya Harding, with the assistance of her ex-husband, Jeff Gillooly, and friend, Shawn Eckart, devised a scheme to hire an assailant to club Nancy Kerrigan in the knee. The plot was carried out by Shane Stant at a practice session in Detroit, causing Nancy to cry out in pain and question "Why?" "Why?" Tonya won the championship that year; but, her victory was short lived. Her ex-husband, Jeff, accepted a plea bargain in exchange for his testimony concerning Tanya's role in the plot. Because of her vicious and envious act, Tanya Harding was stripped of her championship, banned for life from the USFSC, and prohibited from competing in the 1994 Olympics. As Queen Esther's Haman, she was hung on her own gallows.

On the other hand, jealousy is bi-relational-the hater and the rival; it is more personal! There is resentment or bitterness for that specific person. For example, a hater could dislike a rival because she is extremely beautiful, talented, or successful. A jealous person may use an outside force or action to inflict pain directly on her rival, whether the rival deserves it or not. For instance, a hater may become romantically involved with a rival's boyfriend to directly cause pain on the rival. Imagine using and misusing your own body sexually in order to afflict pain on someone else—it does not make any sense to me! I believe jealousy is a deeper and stronger emotion that envy. Songs of Solomon 8:6b echoes my sentiments by stating, *"For love is as strong as death, jealousy as cruel as the grave; Its flames are flames of fire, A most vehement flame [NKJV]."* Acting out of resentment, jealousy can become volatile and, at worse case, it could lead to criminal activity. Crimes of passion usually stems from jealousy--a declared love or a specific love triangle. An angry husband could act out his aggression on a wife and/or lover caught in an act of infidelity.

Jealousy and envy are closely related and can overlap. A hater could hate the rival directly and hate indirectly, due to a particular action or object, as well. Both emotions are fueled by low self-esteem, feelings of insecurities, and lack of worth. *"A woman who has confidence in herself does not waste time planning or reveling in the demise of another person; she rather spend her time advancing and promoting her own gifting." Vickie L. Evans*

What is the best method to deal with a hater? Two of my most favorite biblical heroes are great examples of dealing with haters—David and Jesus. King Saul, filled with insecurities and jealousy for David, chased him and sought opportunities to kill him. Although David, (a skilled warrior) had King Saul cornered on several occasions, and could have wiped him off the face of the earth; David humbly chose not to lay a finger on him.

*5) Afterward, David was conscience-stricken for having cut off a corner of his [Saul's] robe. 6) He said to his men, "The LORD forbid that I should do such a thing to my master, the LORD's anointed, or lift my hand against him; for he is the anointed of the LORD." 7) With these words David rebuked his men and did not allow them to attack Saul. And Saul left the cave and went his way.*

*11) "See, my father, look at this piece of your robe in my hand! I cut off the corner of your robe but did not kill you. Now understand and recognize that I am not guilty of wrongdoing or rebellion. I have not wronged you, but you are hunting me down to take my life. 12) May the LORD judge between you and me. And may the LORD avenge the wrongs you have done to me, <u>but my hand will not touch you</u>. 13) As the old saying goes, 'From evildoers come evil deeds,' so my hand will not touch you." [1 Samuel 24:5-7:11-13 NIV]*

Ladies, this battle is not yours! God reassures us that vengeance is His. How can you lose with the Lord on your side? As humans, it is our nature to retaliate—to get even. However, as this passage states, if you render evil for evil then you are evil and can be classified as a "hater" also!

When dealing with haters, hypothetically ask yourself, "What would Jesus do?" In fact, He was our ultimate example of how to treat a hater! Jesus was spat on, severely beaten, bore a crown of thorns, pierced in His side, nailed in His feet and hands—yet, He never said a word: *"Then the high priest stood up before them and asked Jesus, 'Are you not going to answer? What is this testimony that these men are bringing against you?' But Jesus remained silent and gave no answer [Mark 14:60-61, NIV]."*

74

It is difficult at best to remain silent when you are being falsely accused. Jesus was blameless; yet, he endured the shame and humiliation. He took ownership and possessions of our sins, a task that cost Him his life. Another song I a sang as a child, *"Where would I be if He didn't love me? Where would I be, if He didn't care? Where would I be, if He didn't sacrifice His Life, oh but I'm glad, so glad He did!"*

Are you glad that Jesus left us clear-cut examples for every situation of our lives? Are you glad that He cared enough to offer us the very best? A few days ago, while attending church, I was reminded of why I do not have to worry about "haters". My reminder was written by the greatest poet that has ever lived, King David. Many centuries after his death, many are still reading his profound and melodious sonnets and odes; countless hit songs have been derived from his psalms. My reminder of why I am safe from haters came in the form of my second favorite chapter in the Bible, Psalm 91 (Psalm 37 is my favorite). Psalm 91 is self-explanatory and needs no further introduction:

1. *He who dwells in the secret place of the Most High-- Shall abide under the shadow of the Almighty.*

2. *I will say of the LORD, "He is my refuge and my fortress; My God, in Him I will trust."*

3. *Surely He shall deliver you from the snare of the fowler. And from the perilous pestilence.*

4. *He shall cover you with His feathers, and under His wings you shall take refuge; His truth shall be your shield and buckler.*

5. *You shall not be afraid of the terror by night, Nor of the arrow that flies by day,*

6.   *Nor of the pestilence that walks in darkness,
     Nor of the destruction that lays waste at
     noonday.*

7.   *A thousand may fall at your side, and ten
     thousand at your right hand; but it shall not
     come near you.*

8.   *Only with your eyes shall you look, and see the
     reward of the wicked.*

9.   *Because you have made the LORD, who is my
     refuge, even the Most High, your dwelling
     place,*

10.  *<u>No evil shall befall you</u>, nor shall any plague
     come near your dwelling;*

11.  *For He shall give His angels charge over you, to
     keep you in all your ways.*

12.  *In their hands they shall bear you up, lest you
     dash your foot against a stone.*

13.  *You shall tread upon the lion and the cobra,
     the young lion and the serpent you shall
     trample underfoot.*

14.  *"Because he has set his love upon Me, therefore
     I will deliver him; I will set him on high,
     because he has known My name.*

15.  *He shall call upon me, and I will answer him; I
     will be with him in trouble; I will deliver him
     and honor him.*

16.  *With long life I will satisfy him, and show him
     My salvation." [NKJV]*

Hater, you cannot hurt me!  God will hide me and keep me safe!  If you are being "hated on" know that God has made provisions for you.  Do not retaliate; position yourself under HIS Shadow.   His Shadow alone is large enough to cover us all; there is safety there!  Let me interject, if you are being beaten or domestically violated, and your life is in danger, remove yourself from that destructive situation; and hide under His Shadow in another location.  Do not stay and die! My final words to haters are "haters hate no more!"  There is nothing to gain by it!  Release yourself so that you will not be prematurely forced from the journey because of your hate!

# THE OBSTACLES

# THE WARNING SIGNS!

One morning, while driving to work during rush hour, my engine light came on in my car. I usually do not pay close attention to my car (I will drive it for several months without checking the oil or changing it), until I see a warning light. I was sitting still on I-95, in the far left lane when the engine light flashed red. I put my signal light on and eased my way through the traffic to the upcoming exit. I immediately took my car to *Meineke*™ for evaluation.

The mechanic gave me a laundry list of estimates that did not have anything to do with the actual problem, totaling $404.00. You know how it is when a mechanic sees a woman who is ignorant of mechanics; he seizes the opportunity. After sorting through the rubbish and making him cue in on the problem at hand, the diagnosis was that the engine oil signaler was broken; therefore giving a false reading that my car was low on oil, when it was not. In actuality, it only cost approximately $50.00 to fix this problem. I gained so much spiritual insight from this incident.

Ladies, have you ever met a guy who you thought was perfect in every way, even though the warning signs indicated otherwise? Did you classify those signs as false readings? I know that I have! Unlike my car, I did not give my spiritual senses or as society calls it, my "intuition", immediate attention nor did I proceed with caution to the nearest exit. Actually, I did the complete opposite; I hit the accelerator at full throttle and sped full steam ahead. I did not immediately go to the Father for Divine revelation nor did I get an estimate of what the relationship would cost me. Instead of deciphering through the rubbish (and there was rubbish), I accepted it at face value--blinding me to the false readings. In my reflections, a portion of Proverbs 3 began to ring in my head..."In all thy ways acknowledge

Him, and He shall direct your path..." In addition, I hear a song playing in my mind; I believe it is Mystical and it is saying "Danger!" (I know you all are wondering how I know so many hip-hop artists but I have sons!) Anyway, obey the warning signs; it could save you so much heartache, headache, and depression; not to mention, the savings could be phenomenally less ($50.00 in comparison to $404.00 is a lesser dent to the pocketbook). Do not let "Slick-talking Willie" rob you of your self-esteem! Sharpen your discernment skills! If your oil signaler is broken; get a new one right away – it could save you from "false readings". Listen to friends and loved ones who truly have your best interest at heart. Rid yourself of the detractors, associate with those who add value and build strong and fruitful relationships.

You need to know that delay is not denial – the man tailor-made for you is on the way. Praise God for the delays in your life. I am so thankful for the delay that I had with my car that morning for two reasons: 1) This delay could have been a means of preventing me from encountering serious danger up ahead; and 2) God can speak to you one-on-one during the time of delay. He could be saying, "Wait, you are getting ahead of me!" "Follow Me!" "You just made a wrong turn!" "You're going down a one-way street!" "You are approaching a dead end!" Heed the warning signs--stay on course with the journey!

# MONEY "AIN'T" EVERYTHING
# – BUT FAVOR IS...
# (Understanding Your Source!)

*"For the love of money is the root of all evil: which while some coveted after, they have erred from the faith, and pierced themselves through with many sorrows." [1 Timothy 6:10 KJV]*

Empires and dynasties have crumbled because of it! Love ones have betrayed their own families as a result of it! Women have sold their "precious bodies" to obtain it! Yes, the **love** of money is the **root** of all evil. I wonder what would happen if all the money in the world was put in a giant incinerator and burned to a crisp; what would your reaction be? Is your value system based on the amount of money you earn? Would your faith in money or the lack thereof cause you to lose your hope, joy, peace, or sanity? Would you feel hopeless, despondent, depressed, or even suicidal? It is my guess that some of the individuals who experienced the Great Depression of 1929 possibly would have answered "No!" to these probing questions -- until it happened to them. "Sadly, some were so overcome with despair and hopelessness that they climbed on tall ledges and jumped out of windows. By noon on Black Thursday there had been eleven suicides of fairly prominent investors. Others drank themselves to death or just disappeared." [12] Some people value money and what it can buy more than they value human life. How real is money to you? Is it everything to you? Do not get me wrong, I like money and value what it can gain me access; however, a series of incidents changed my perception of its ranking of importance in my life.

In November 2004, I went to support a fellow minister (Yolanda) who was celebrating her church's first year anniversary in District Heights, Maryland. It was a joyous and wonderful occasion. After the service, I walked to my

brand new 2004 Dodge Intrepid only to discover that the
steering column had been fractured with a brick.
Fortunately for me, after the carjackers smashed the
steering column, the ignition locked, making it impossible
to hotwire the car. After making several calls to 911, and
waiting three long hours for police assistance--which never
came, (oh, excuse me, let me correct that: a Washington DC
policeman arrived only to tell me that I had just crossed
over the DC line into Maryland; therefore, I was out of his
jurisdiction—and then he left us two ladies, at 9:00 at night,
on that dark, secluded street, adjacent to a warehouse,
without calling in my problem, or any other assistance.). I
finally called a towing company and had my car towed to a
local body shop. My friend, Yolanda, and I both lived in
Virginia, so she offered me a ride home. While sitting in her
car, awaiting the tow truck, I expressed to her that I did not
have a clue how I was going to pay the $500 deductible that
my car insurance company required. She reached into her
glove compartment and handed me $500.00 (Thank God
the carjackers did not break into her car!). I asked her if she
was loaning me $500.00 and she replied, "No, I am giving it
to you!" This act of kindness touched my heart because I
had only known Yolanda for three months and had only
seen her three times prior to this incident. Now, she is
giving; not loaning me a large sum of *money*? I was not
accustomed to this type of generosity. When, I questioned
her motive concerning it, she replied, "Money Ain't Real!"

At first, I looked at her strangely because I was a bit
confused about this revelation. My perception has always
been that money is definitely real. I need money to pay my
mortgage, my utilities, and car note, and to buy food, and
pay for my frequent excursions to the local malls; so how
could it not be real? However, the next few months took me
on a journey of faith that changed my outlook on money.
Actually, the journey began prior to Yolanda's revelation but
I began to see it more clearly after this attempted "larceny".
Approximately a year prior to this incident, I received
Divine instructions to go to a local event center to request
assistance for my $1,200 electric bill (it was several months

in arrears because I lost my job a year earlier, and was trying to make ends meet with the minimal resources provided by what we refer to as "unemployment"). Being a woman with some pride issues, I could not conceptualize or rationalize asking money from a complete stranger to face the embarrassment of being turned down. However, without a doubt, I **KNOW** Divine Instructions when I hear it! The scripture relays in John 10:27, "My **sheep** listen to my **voice**; I **know** them, and they follow me **[NIV]**. Well, I mustered up enough courage and thought it was worth a shot. I went to the Event Center and asked for the Center's Director. To my surprise, she was not in and I was given the option to leave a message-- which I did. Inadvertently, the director's absence altered my faith a little and I began to question why God would send me to that Center knowing the director was not there (Just because I know the Voice of God does not  mean I always understand the plan - smile). Yes, the trying of your faith certainly does work patience! The next morning, I woke up early enough to watch the television evangelist, Joyce Meyers, my usual routine. That morning, Joyce spoke words that resonated as loud as if she was using a megaphone through the television. She said, "For your faith to be activated, you have to step out of the box, and do what you never did; be radical!" The same day the Center's director (who is a Christian minister) called me and I told her what the Lord told me. She replied, "It is not our policy to give charitable donations but if you say the Lord told you, I will pursue it." The next day she called me and told me that she met with the Center's board of directors and that they agreed to pay my bill. In addition, she had called the electric company and discovered that a new billing cycle had begun and an additional $200.00 had been added. She then informed me that she had mailed a check to the electric company, for the full amount of $1,400, from the Center. That minister/director is my friend today. ***This lesson taught me that the Favor of God can unleash immeasurable treasures from Heaven and dispense it in the Earth realm through unexpected sources.*** Karen Clark-Sheard said it best in her song entitled, "*Favor*": ***"When you pray, He will***

*answer! Ask for rain, and watch it pour!" This is the hour, I'm pouring out—my Favor!* And pour it did indeed in the tune of $1,400!

As I stated previously, a compilation of events occurred after Yolanda's revelation that convinced me that the Favor of God is better than money: Those incidents were:

1) My second husband walked out and left a check on my nightstand that said "Final rent check". He did not have the decency to inform me that he was leaving first; instead, he told my son, who informed me! I was devastated!

2) After four months of employment, a long-term, seven year employment contractual agreement with a governmental agency ended abruptly and prematurely due to financial mismanagement. What a difference a day makes. When I left work the day before I had a job; 24 hours later I was jobless. This occurred in the midst of finalizing the process of purchasing a home. In addition, my only daughter was engaged to be married in a few short months, and was depending on me to cover half of the expenditures (and it was a very extravagant wedding indeed).

All of these events could have cost me my sanity. Here I was with no love, no job, a wedding to pay for, and deflated hopes of purchasing a home; however, Favor turned my circumstances around.

This is what Favor did for me:

1)     Favor blessed me with another job the very next day. However, the official start date was scheduled one month after I was hired. During that month, I received severance pay from my previous job, an unemployment check, plus an extended month's vacation (smile).

2)  On top of that, I wrote a contract on a house
    and the loan was approved without having a
    job (Absurd, huh?). In addition, the seller
    agreed to pay $5,000 of my closing cost. My
    scheduled mortgage payment doubled my
    current rent payment; however, my salary did
    not double. Yet, the Favor of God
    consistently "stretches" my income to make
    provisions for me. Honestly, I do not
    understand how I survive based on my salary
    in comparison to my expenditures. If not for
    the Favor of God, I would be homeless and
    hungry today! Thank you Father, for shining
    your Favor of Love on me, even when I do not
    have money!

The most important lesson that I learned from all these
experiences was that my job is not my source; it is my
resource-- a means by which God has selected to manifest
His provisional blessing. God is the true Source of my
being; His Favor is priceless! When God is on your side--
who can be against you? God spoke to Abraham in Genesis
12:2 saying: ***And I will make of you a great nation,
and I will bless you [with abundant increase of
favors] and make your name famous and
distinguished, and you will be a blessing
[dispensing good to others] (Amplified Bible)***. I am
the dispenser of God's blessings. I am the salt shaker that
dispenses the salt. The latter part of Matthew 10:8 also
instructs, ***"freely ye have received, freely give"***. I
may not have millions; but such as I have; I freely give—like
Yolanda did. You have to put your trust in the original
Director of Treasury—[God] the manufacturer, and
dispenser of the money; instead of the money itself. When
you know your worth and you know who Your Source is;
you can quote Psalm 121, the very first responsive reading
that I ever memorized as a child, in my church, Mt. Pleasant
Baptist, in Sugar land, Texas. It really sums up who God is
to me:

### Psalm 121

1.  I will lift up my eyes to the hills from whence
    cometh my help. **(My Help)**

2.  My help comes from the Lord which made
    heaven and earth. **(My Source)**

3.  He will not suffer thy foot to be moved, he that
    keepeth thee will not slumber. **(My Support)**

4.  Behold he that keepeth Israel shall neither
    slumber nor sleep. **(My Watchman)**

5.  The Lord is thy keeper the Lord is thy shade
    upon thy right hand. **(My Covering)**

6.  The sun shall not smite thee by day nor the
    moon by night. **(My Sunscreen)**

7.  The Lord will preserve thee from all evil, he
    shall preserve thy soul. **(My Preserver)**

8.  The Lord shall preserve thy going out and thy
    coming in from this time forth and even for
    evermore. Amen." **(My Eternal One)**

Furthermore, "Heaven and Earth will pass away,
but My Source will remain forever. *If you are
connected to The Source, when your money
is funny, and your spirit is low, you can
connect your jumper cables to the main
Power Source and re-energize yourself!*

In summary, faith and favor can open doors that appear to
be nailed shut. Faith and favor can change the intentions of
a man's heart. He may have had every intentions of telling
you **"no"**, however; God turned that **"no"** into a **"yes"**!
Have you ever had someone tell you, "I don't know why I

am doing this for you; I just am." Some of you are working in careers for which you are not qualified; living in homes that you could not normally afford; and driving cars that are you never thought you could obtain (Mercedes, Jaguars, etc.); and it is all because of the Favor of God. Some of you are probably thinking, "I have worked hard for everything that I have!" True, but the Favor of God opened up the door of possibility and gave you mental capability and good health that permitted you to "work hard; there are some unemployed and even homeless individuals with Masters and even Doctorate degrees- so it is not your intellect!

I understand the concept of "money ain't real" because it is not the money; it's the favor and power that you obtain because of it. For example, Oprah Winfrey could probably walk into any store around the globe and verbally make a purchase without producing any physical money. I am sure that no one has visually seen the billions of dollars it has been reported that she is worth; but by the word that has been spoken; and the Favor of God which has graciously gifted her to produce wealth; it is just taken for granted that she is worth it. She could probably make a phone call or take out her black titanium *American Express* ™ card, and the transaction would process at her word. Very few would debate or try to validate that she is worth more or less than the reported figures of what she is worth; it is just accepted as face value because of the favor she has found in the public eye, or the credibility of the source that supplied the information that she is worth billions. If *Fortune* or *Forbes* magazine lists her as a billionaire – then it is accepted because of their reputation of being the experts in financial matters. How much more powerful is the Favor of God? He spoke an entire universe into being. He said, "Let there be light!", and there was light. Besides, He paid a price for us that no other price tag can match—His Life. Therefore, His Favor takes precedence over money.

Undeniably, there are many things that money can buy; yet, there are some things that it cannot. It cannot buy you health, happiness, or life. Someone sent me an appropriate

poem via e-mail that details what money can and cannot buy:

***MONEY***

***It can buy a House***
***But not a Home***

***It can buy a Bed***
***But not Sleep***

***It can buy a Clock***
***But not Time***

***It can buy you a Book***
***But not Knowledge***

***It can buy you a Position***
***But not Respect***

***It can buy you Medicine***
***But not Health***

***It can buy you Blood***
***But not Life***

***It can buy you Sex***
***But not Love***

***So you see money isn't everything.***

Corruptible (tangible) things are good to have but it is the incorruptible things (intangibles like love, joy, peace, etc.) that last forever. That is why I would rather have Jesus than all the silver and gold in this world. Kirk Franklin wrote a song entitled "Silver and Gold" that states: ***"Silver and Gold! Silver and Gold! I'd rather have Jesus than silver and gold! No fame or fortune, no***

*riches untold, I'd rather have Jesus than silver and gold!"*

Why?  Because He is my "Source"!  He is infallible; He has a proven track record!  Moreover, He sustains me on the journey!

# I HATE MY JOB!
## (The Call to Entrepreneurship)

### *"I Can't Take This Another Day!"*

How many of you absolutely hate your job? You dread the start of your day, knowing that you are going to spend eight hours doing something that you absolutely hate! Do you spend countless hours wishing you were somewhere else doing anything beside what you are doing? Is the most exciting time of your work day, at the end of the day, when you walk out the door? Do you go to bed at night depressed, knowing that you have to wake up the next day to repeat this vicious and useless cycle? A local newspaper, *The Washington Post*, aired a commercial advertising their Mega Jobs section that expressed my sentiments. It shows a green parrot in the middle of a man's living room. The parrot is saying repeatedly, "I Can't Take This! I Can't Take This! Another Day! Another Day!" Seconds later, a man drags himself into the house looking disoriented and disheveled saying, "I Can't Take This! Another Day!" Initially, I identified with his downtrodden state of hopelessness, until I heard and heeded "The Call". You know, "The Call", that solemn voice resonating deep within your soul--beckoning you to come--whispering in your ear--burning in your sub consciousness--nudging you in your side--taunting you day and night--and disrupting your sleep. It is calling you like a howling wind, vehemently beating against your window of opportunity. It is calling you to align with your purpose, to assume the posture of leadership! You have successfully utilized your gifts to profit others and to elevate them to the top of the corporate ladder; yet, you have received little to no recognition for your gifts nor were you compensated equitably. Some of you have mastered your gift and have acquired multiple certifications and degrees to prove it; however, you still have not achieved or received your net worth. Some of you

have been "wooed" away from "The Call", settling for a "promise of retirement" which conditioned [brainwashed] you to commit 20-plus prime years of your life to a particular career track, so that you could be compensated 1/3 of your worth for the rest of your life. With the present economic condition of the world, many will have to acquire a part-time job to add with their retirement, just to meet their daily expenses.

What is this call?  It is your gift of entrepreneurship. However, I must interject; this "call" is not for everyone; only a remnant is equipped to handle this assignment. The synonym of entrepreneurship is enterprise, *"readiness to engage in daring or difficult action" or "a project or undertaking that is especially difficult, complicated, or risky."* [13] As the definition implies, the call to entrepreneurship is not easy and involves risk-taking. The Bible equates risk with "launching out into the deep" [Luke 5:4 KJV]. You cannot reach your destiny by staying in the boat.  You must take a chance and move farther away from your present situation than you could ever imagine. There will be times when you feel that you are in the middle of the ocean with no dry land in sight.

*Entrepreneurship requires discipline, organization, stewardship, leadership, relationship, endurance, integrity, assertiveness, and faith in God and yourself.* Ladies, some of you are extremely talented, with multiple gifts and multiple streams of income.  Many of you have enormous potential to be the greatest business owners with the ability to make billions of dollars; yet, many have not tapped into that potential.  A wise person once said that the richest place on earth is the graveyard.  Dr. Myles Monroe profoundly declares in his book, *Understanding Your Potential*, *"Tragedy strikes when a tree dies in a seed, a man in a boy, a woman in a girl, an idea in a mind.  For untold millions, visions die unseen, songs die unsung, plans die unexecuted, and futures die buried in the past."* [14]

Although I strongly advocate college education; education is not always a prerequisite for entrepreneurship, some of you have natural entrepreneurial skills and abilities.  I know this is an extreme observation, but I have always been curious how some inner-city crime bosses and drug dealers have formed, led, and managed very large cartels without formative education or training; yet, there are many educated individuals with masters and doctorate degrees, who are sitting in dead-end jobs, wasting and ignoring their entrepreneurial skills and abilities.  There have been many successful entrepreneurs and inventors who did not have formative education or training:

- At 16, **Henry Ford** left home to become a machinist.  Later, he invented the Model-T, and established the Ford Motor Company.

- **Walt Disney**, the founder of Disneyland and Disney World, dropped out of high school at 16.  His first company, Laugh-O-Gram, ended in bankruptcy.  Today, the Disney company earns an annual revenue over 30 billion dollars.

- **CoCo Channel**, fashion designer and perfume manufacturer was an orphan for many years.  Starting as a seamstress, she created bold fashion and styles for women that were commonly reserved for men.  She is one of the few and forerunner of women who created perfumes that bears their name.

- **Debbi Fields**, better known as **Mrs. Fields**, started as a 20-year old housewife with no business experience.  She is the now the most successful cookie owner.

- **Dave Thomas**, founder of the food franchise, Wendy's, dropped out of school at age 15, to become a bus boy.  After a brief career with the

military, Dave was instrumental in helping Kentucky Fried Chicken gain its notoriety, transforming them into a multi-million dollar enterprise. Soon after, Dave established Wendy's and made it into a multi-million dollar business. Dave did complete his GED several years later.

- **Tyler Perry**, movie, theatre, and television producer, and playwright, was expelled from high school two months prior to graduation. Once homeless, he is now a multi-millionaire, founder of Tyler Perry Studios, trailblazer, and inspiration for millions of playwrights (me included).

So you see the lack of education can no longer be used as a crutch for not heeding your "call" to entrepreneurship. You have "the gift"; you need to use it! Personally, I have no formalized training in journalism, creative writing, or play/scriptwriting; yet, I believe I am one of the greatest writers that have graced the face of this earth. I have confidence in the gifts that God has given me to profit.

Ecclesiastes: 5:18-19 confirms:

*18) Behold that which I have seen: it is good and comely for one to eat and to drink, and to enjoy the good of all his labour that he taketh under the sun all the days of his life, which God giveth him: for it is his portion.*

*19) Every man also to whom God hath given riches and wealth, and hath given him power to eat thereof, and to take his portion, and to rejoice in his labour; this is the gift of God.*

Many of you have not utilized, rejoiced in, or benefited from your gift of entrepreneurship at all; it is buried in what I refer to as "The Can of I Can'ts". "I can't because it is not

the right time!" (When is?) "I can't until my child finishes college!" (I could see if he/she was in grade or high school-- but college?) "I can't because I do not have the finances!" Take note, some entrepreneurs "start-up capital" was lemon, water, sugar, and a lemonade stand at the age of 6! "I can't because I am a woman, and this is a male-dominated society!" I agree, there was a time period when women were excluded from the corporate arena, but that day is over! Women entrepreneurs such as- Oprah Winfrey – media mogul, producer, actress, owner of Harpo, Inc., and host of the internationally syndicated *Oprah Winfrey Show,* "the highest-rated television show in the history of television" [15]; Cathy E. Hughes, owner of Radio One and TVOne, "the first African American woman to head a firm publicly traded on a stock exchange in the United States." [16]; Anne Mulcahy, chairman of the board and chief executive officer of Xerox Corporation – who was listed in Forbes magazine "in sixth position among the "Most Powerful Woman In America in 2005" [17]; and Senator Hillary Rodham Clinton, former First Lady, who in 2008, contended for the highest office in the United States, The Presidency, have shattered the glass ceiling that once prohibited women from achieving their dreams. Just as the glass ceiling has been shattered; so have your excuses. Stop placing limitations on yourself! You are innovative and creative; find a way! I have a friend who is a risk-taker. She has established and ventured out on countless of what I call "fly by night" business schemes, in which she always summoned her friends to join her. Each project had short success or completely "flopped"; however, my friend NEVER GIVES UP! She moves on to the next business venture and embraces it wholeheartedly. I have said and will continually say that one day she will be a multi-millionaire because one day the "right" business venture is going to meet up with her "Divine Purpose" and she will strike oil. I admire her freedom and her ability to take a risk, fearing nothing!

Fear is the dragon's most effective weapon. He has used it to try to "kill", "stifle", "burn", and "destroy" the hope and

dreams of so many of us who are "pregnant" with the call of entrepreneurship. You are standing on the brink of prosperity; yet, fear has you by the neck, slowly strangling out your ability to breathe life into your multi-million dollar enterprise. He is blocking your birthing chamber, prohibiting the head of the corporation – the chief executive officer – from acclimating to her position on the top of the organizational chart. Not only is he [the dragon] trying to annihilate you, but he is trying to commit genocide on your legacy—your children, and your children's children. He knows that many will be "blessed" by the product and/or service that you will provide for years to come, only if you would recognize and discover your worth! One of my favorite songs, "Let Go!" is by a gifted psalmist named, Dewayne Woods. The hook in that song says:

*"As soon as I stop worrying,*
*Worrying how the story ends*
*I let go and I let God*
*Let God have His way*
*That's when things start happening*
*When I stopped looking at back then*
*I let go and I let God*
*Let God Have his way"* [18]

As a side bar, Dewayne Woods was diagnosed with and healed of HIV/Aids. He acknowledges his faith in God as the reason for his complete healing. Entrepreneurs, you have to replace that fear with faith, for without it, you cannot please the Lord [See Hebrews 11:6]. You have to exercise your faith in order to be an entrepreneur.

Another truthful scripture states that "Faith without works is dead [James 2:20]." That means that you have to show initiative; take action! Once you MOVE, God will MOVE (just like that). Have you ever watched a movie when a car is involved in a high speed chase and the only thing in front of the driver is a cliff? All of a sudden he drives off of the cliff (you hold your breath) and the car lands without a scratch or harm to the driver. Or, what about a skydiver

jumping out of a plane with just a "little-bitty" parachute and landing safely on the ground without a hitch?  Well ladies, that's my impression of walking by faith – you cannot see where you are going but you are confident that you will reach your destination safely. However, you have to "Let Go and Let God"!  *"Trust in the Lord with all your heart and lean not to your own understanding.  In **ALL YOUR WAYS** acknowledge Him and He shall direct your path."* [Proverbs 3:5-6, KJV]  So there you have it, your formula for becoming an entrepreneur.  If you are called and know it, there is nothing left for you to do--but to do it (fulfill the call)!    Say Yes!  Be a contributor to the journey...!

# THE COUNTERFEIT
## (A Roadblock to The Real Thing!)

Ladies, I am going to start this chapter out with an admission – I am a shopaholic! Shoe shopping is one of my favorite pastimes. Subsequently, during one of my shopping excursions, I received the meat of this chapter. In one of my favorite department stores, I found a simply gorgeous "name brand" pair of brown ankle boots, pointed-toed, with a skinny 3-inch heel, which incidentally, were on sale. To my surprise, sitting on the same shelf, was an identical pair of "no-name brand" brown ankle boots that were priced fifty percent less. I tried them both on -- both were as equally attractive and both appeared to be comfortable. The major difference was that the "name brand" was made of leather, and the "no name brand" was all man-made material. The leather indeed was more flexible, supple, and soft; however, I chose to buy the one that would save me the most money. The next day, I put on my "no name brand" boots and headed out to a busy work day followed by an eventful social evening that require me to be on my feet for several hours. Midway through the day, I began to regret my decision to buy the "no name brand" shoes. My feet began to hurt so badly! The longer I stood on my feet, the tighter this man-made material began to feel. I began to think back on how soft and supple the "name-brand" shoes felt on my feet and began to think about one of the characteristics of leather. Leather usually softens as you wear it, instead of tightening up. Oh how, I truly wished that I had spent the extra dollars to purchase the name-brand shoes because in the long run it cost me more in other areas. What looked good, and initially felt good, was now causing me great pain. I had to face the revelation that I had settled for the counterfeit.

I decided to go back and purchase the "name brand" shoes, but you guessed it – they were no longer available. Ladies, how many of us have "missed opportunities" to experience the real thing because we settled for the counterfeit?

During one of my conversations, with my spiritual mother, Eloise Rump, about my desire for companionship, she said "Baby, be watchful! The counterfeit always come along before the real thing!" I chuckled within myself and said, "Well, I am really due for the real thing soon because I have had several counterfeit encounters. Little did I know that the "ultimate counterfeit" experience was just right around the corner!

Ladies, have you ever met the man who you thought was your "soul mate"? He had all the characteristics on your "romantic wish list". You know that "must have" check list that we mentally pull out when we meet a man! The first and foremost requirement of my "wish list" is spirituality – He must have a relationship with God. Well this man "quoted scriptures" and talked affectionately about the Lord. Ladies, I became enlightened that the mere quoting of scriptures is not a foolproof indication that a person has a "personal" relationship with God; the real indication is if that person lives/abides by what he speaks". Call me Missouri, show me, as well as tell me!

My second requirement is that he has to have a fairly decent job. Well, he had an exceptionally high six-figure salary, so that requirement was exceeded. He certainly had the finest personal possessions – a nice house, a luxurious car, and other nice amenities, as well. Although, I love nice things, this requirement is not at the top of my list. However, at this point in my life, financial security is important to me, and he apparently met that requirement.

Of course, my third requirement is that I preferred him to be handsome. I feel that I am an attractive sister so I want someone who would compliment me. I know that sounds like vanity, but please admit ladies, most of us dream about having a Denzel Washington or Shemar Moore in our lives. Remember, this is my "wish list"! Ladies, I must tell you that this man is fine, fine, fine! To me, he has facial attributes comparable to Denzel Washington but a shade darker and the physique of Ving Rhimes both who are on my list of "hotties"! (I am single—I can dream!)

Last, but not least, one of my top attributes is that my potential partner has to be a great conversationalist! I love great conversation--it stimulates me when a man can articulate his feelings to me! I love a man who is confident and assured of himself. I love a man who is wise and implants pearls of wisdom that enrich my life. Well ladies, this man stimulated me intellectually with his broad range of knowledge of national, international, and cultural affairs. My God, he appeared to be perfect, just like my "no name" brand of boots. But as time progressed, I realize that what appeared to be "perfect" was actually counterfeit.

The first revelation was that although this man appeared bold and confident, and as if he was completely in charge of his life, he was carrying baggage from his past. *A man who has not forgiven, forgotten, or forgone his past, will not release himself to start something new.* He has not given himself permission to love again without inhibitions – the way he loved before that "one" hurt him. In fact, he has made a vow that no one will ever get that close to him to EVER hurt him again, like she did, so he is encased in a protective shield. He has what I describe in my first book *The Art of Forgiving* - **Turtle Mentality**. He only sticks his head out so far and then retreats or throws up the red caution flag when he finds his affections getting too deep. His behavior is inconsistent – one day he is loving, kind, smiling, and chatting away. However, without warning, you do not hear from him for days – he does not call you, e-mail you, text you – nothing. Face it ladies, you cannot compete with a ghost. Yes, I said ghost! Merriam Webster (on-line) defines "ghost" as *the spirit of a dead person, especially one believed to appear in bodily likeness to living persons or to haunt former habitats*. Answers.com defines "ghost" as *a returning memory or image*.

What I am trying to say is when you interact with this person; there are actually three people always present – you, he, and she (the ghost). Even though the relationship appears to be dead, the memories of her are very much

alive. This looming image of her and the residue of the hurt that she previously imposed, returns, haunt him, and affect his potential relationships. There could be a look, a word, an action – unbeknown to you – that may cause him to retreat into that shell because it resembles "her". An attempt to validate his actions may sound like, "I am content with my life the way it is, I do not have to answer to anyone but me, and I am at peace with that!" Another explanation, "I went out with "my boys" to shoot some hoops." My interpretation of these excuses is "I like you and I am scared that you might get too close and hurt me the way that she did; I cannot let that happen, so I rather avoid contact with you and spend times with "my boys", or in the case of my counterfeit, he spent time with his child. Both incidents, whether spending time with "the boys" or a child, is a recoil to safety and does not require taking a risk with his feelings! However, as women, we see the recoil as rejection, which sends us on an emotional mental rollercoaster because we do not know what to make of this sudden change of behavior. We look for some type of flaw in ourselves that may have caused him to retreat; unaware of the unresolved issues he is carrying that he has not communicated to you – that is verbally anyway.

At any rate, unless he makes an attempt to commit to the relationship; there is no REAL relationship; it is counterfeit; and before you know it, he will begin to make you feel uncomfortable, just like my no name brand shoes. The longer you stay in the situation, the tighter it will become. The tighter it becomes; the more hurt and pain you will feel. But if you wait for the "real thing", it will be soft and supple—easily entreated, and a joy to be around. No relationships are without problems; but when you have two committed individuals who are ready and willing to work together—free of baggage and ghosts, you will have a comfortable fit that will be long lasting. Ladies, do not settle for the counterfeit. As the late duos, Marvin Gaye and Tammi Terrell expressed—*Ain't Nothing Like The Real Thing, Baby!* Wear the right shoes for the journey!

# CELIBACY
# (The Right Choice!)

As a Black, middle-aged, divorced, Christian woman, I find myself facing a challenge that I never imagined I would have to face – celibacy – abstinence from sexual relationship. We live in a time period where sexual promiscuity is as prevalent and as routine as the changing of outer garments. Old fashioned courting and dating is simply considered that – "old fashioned" and "out dated". Words like celibacy and abstinence are nearly obsolete. Even though I may be considered in the minority, I proudly proclaim that I am celibate. External situations and circumstances may have led to my condition of celibacy; however, I am celibate by choice and not by force.

Single ladies, (who are virgins) I am sure that abstinence is difficult for some of you especially when you are around married women who have experienced sexual bliss. However, it is more difficult for divorcees having experienced intimacy and then being forced into abstinence suddenly, sometimes without warning. For me, it is in comparison to a drug addict trying to self-rehabilitate by going "cold turkey". Therefore, you try to compensate for your loss by working long hours or finding hobbies to distract you. Nevertheless, no matter what the circumstance, celibacy is the correct choice.

Several factors influence my decision of celibacy:

At the top of that list is my spiritual conviction. Before my personal commitment in accepting Jesus Christ as my "personal Savior", celibacy may not have been my choice; believe me--I have not lived a "perfect" life. In fact, I could tell you some things NOT to do concerning relationships. I accentuate the words "personal" because for many years I went to church and even professed to be saved (I feel that

we as Christians use the term "saved" too loosely.);
however, I really lacked the "total commitment" to Christ,
and did not know Him in the manner as I currently know
Him. Admittedly, I still have more to learn! The key reason
that I am celibate is because the Bible says that intimacy is
for those who are married, which I am not. That is simple
and does not require too much explanation; I could really
stop right there, but I want to interject a scripture for those
of you who would like to challenge the issue: ***"Honor
marriage, and guard the sacredness of sexual
intimacy between wife and husband. God draws a
firm line against casual and illicit sex [Hebrews
13:4, The Message Bible]."*** My love for God is so strong
now because He has proven to be "Faithful" and "True"
more times than I can count. So if He says **"No!"**, then it is
**"No!"** Enough said!

Another reason for my celibacy is my desire to rebuild
strong family values. Divorce is a VERY "ugly" word and
has a way of making you question your family values and
your desirability as a woman! I admit that it was not easy
transitioning from being married after 19 years, with the
free will to experience intimacy without restrictions, to
being single with the sudden lack of intimacy; there were
certainly some very restless and lonely nights. There were
also days when I questioned whether any other man would
find me attractive. I quickly discovered that there were
many others in the same boat. According to the *New York
Times*, in an on-line article published January 21, 2007, "51
percent of all women live without a spouse" and "half of all
men find themselves in the same situation".[19] Also,
"according to the latest government figures, African
American couples are divorcing at a higher rate than either
whites or Hispanics. The divorce rate for Blacks currently
stands at 12 percent. This compares to 10 percent of white
couples divorcing each year and 7 percent of Hispanic
couples".[21]

These statistics are equally alarming and saddens me since I
am both – Black and a woman. When I was a child, the
Black race was built on a solid foundation, enriched with

close-knit communities and rooted in spiritual values. Our family structure was primarily comprised of a hard working father, a strong nurturing mother, and well-mannered children; similar to the images portrayed in the popular 70s sitcom, *Good Times*. Now, we lead the statistics in divorce? This is not the "dream" that Martin Luther King, Jr. envisioned. We are definitely facing a crisis – a vast number of the heads of our households no longer look like "James Evans"! Far too many Black women (me included) are working outside of the home and are primarily the sole "bread winner"; we do not look like "Florida Evans", the nurturing mother waiting with open arms to meet, greet, and provide "life-changing" guidance to her school-age children. As a result, our children are suffering! How can we achieve balance and find our way back to our **Roots** or is the Black family, as we know it, facing extinction? What does this have to do with celibacy, you ask? Well, although I have experienced some "war wounds" from the battle of divorce, I still believe in the sanctity of marriage. Without a shadow of a doubt, I believe the family structure that has been embedded in my mind from my childhood is STILL accessible and possible because God is still God. Therefore, I will marry again, but I WILL wait on the Lord to send and orchestrate the mate who is hand-selected just for me, because I am special and I "know my worth"! No ordinary man can deal with me because I am not an ordinary woman (smile)! When he (my groom) comes, he will find a bride who is "single and whole, confident and bold; spiritually Divine with an innovative mind"!

My third reason is because I practice "safe" sex! My definition of "safe sex" is "no sex" until marriage. Disturbingly, HIV/AIDS is running rampage in the Black community. "Blacks account for more HIV and AIDS cases, people estimated to be living with AIDS, and HIV-related deaths than any other racial/ethnic group in the U.S. Although Black Americans represent only 12% of the U.S. population, they account for half of AIDS cases diagnosed in 2005 (See Figure 1). Black women account for the far majority of new AIDS cases among women (66% in 2005); white and Latina women each account for 16% of new AIDS

cases. Black women represented more than a third (35%) of AIDS cases diagnosed among Blacks (Black men and women combined) in 2005; by comparison, white women represented 15% of AIDS cases diagnosed among Whites." [20]

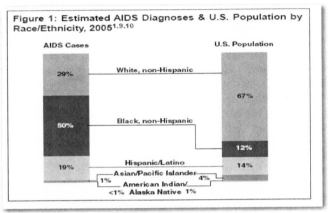

Figure 1 [21]

That's enough for me to make a conscious decision to exercise caution in determining with whom I will spend my future; it is a matter of life or death! Although I realize there is no "foolproof" way to determine if a person has HIV/AIDS, and that this disease can lay dormant for many years without the symptoms being manifested, I choose to form a friendship first with a potential mate to determine what type of morals, values, or integrity he has. A man with character and integrity would care for my well-being, would not endanger me, and would not withhold life-threatening information from me. With the mutual respect that we have for one another, we will surely create a long-lasting, committed, and intimate relationship. One of the quotes that I coined is: *"Short-term limitations lead to long-term relations!"* Besides, I believe intimacy starts long before the sexual relationship. A smile, a touch, great conversation (I love great conversation), and holding hands, are some ways that sparks passion in me. If a man cannot

turn me on outside of the bedroom; he certainly cannot turn me on in it!

Another reason that I choose celibacy is because I refuse to allow good sexual relationships to mask or deter me from getting to know the true intentions of a man – now that I know better. Sometimes it is extremely difficult for women to control our emotions, especially after we have been intimate with a man. Oftentimes, "red flags" of warnings flash in front of our eyes and we ignore it because of the "sweet nothings" whispered in our ears during the heat of passion. As I said previously, I am not perfect, and I will be the first to admit that in previous relationships, I allowed good sex to take my focus off the character and heart of the person. I am not the woman who can testify that I have only had one sexual partner and that the only man with whom I have been intimate was my husbands. Therefore, I can speak of the "soul ties" that form when you have intercourse outside of the bonds of matrimony. Both parties are depositing a part of themselves into the other – which they will never be able to get back. Not only have physical residues been left behind, but mental and emotional sentiments (especially for women) have been transferred, also. He will always be a part of your history – a bond that can never be severed – even if he is a one-night stand, he has joined himself with you through spermicidal exchange. You may try to forget him or forget the experience; however, he entered your temple—your holy sanctimony. 1 Corinthians 6:19 refers to your body as "a temple of the Holy Spirit". Treat your body like the temple of God that it was created to be. Now that we know better, we have to do better! If you are single or divorced as I am, let God be your Husband until He releases you to your mate. I know you may have difficulty accepting that literally, but truly, if "you walk in the Spirit, you will not fulfill the lust of the flesh" (see Galatians 5:16). I am a living witness.

Finally, I am a woman who precisely knows what she wants in a relationship and I am not afraid to express it! I know some men are intimidated by that but it really is an

admirable trait. In me, you will find a woman who is honest and forthright, who will not leave you guessing! Wow, that sounds like a profile for a dating service (smile). One morning, while listening to a write-in segment of my favorite nationally syndicated radio show; a male viewer wrote a letter concerning a woman he met to whom he referred to as "his Queen". He said that at the onset of their relationship, this woman told him what she desired and what she would not tolerate in a relationship. He revealed that her "frankness" scared him because he had never met a woman who knew exactly what she wanted. That's a sad statement! Women, we need to know what we want in a relationship, state it, and stick to it! How can we find the man who enhances us physically, spiritually, and mentally, if we do not know or make known what we desire? The Bible states that "A double-minded man is unstable in **ALL** his ways" (that includes a woman also). Furthermore, what will you offer him so that he will not feel that he waited in vain? Someone said - if I am not mistaken, I believe it was Bishop T.D. Jakes, "Do not wait until you get married to become a wife; practice being a wife now!" Take care of your body, soul, and spirit. Concentrate on loving yourself and loving God equally; then it will not be hard to wait! Put away the S.E.T. (Sexual – Enhancing – Toys) and put on the whole armor of God. Ephesians 6:10-11 states, ***10) In conclusion, be strong in the Lord [be empowered through your union with Him]; draw your strength from Him [that strength which His boundless might provides].***

***11) Put on God's whole armor [the armor of a heavy-armed soldier which God supplies], that you may be able successfully to stand up against [all] the strategies and the deceits of the devil.***

I have made a conscientious choice to exercise power over my body, and to wait on my mate. Just like the old saying, "Good things come to those that wait!" I am confident that celibacy is definitely the right choice for me – what about you? Endure the journey with patience!

# TOO MANY "SUGAR MAMAS"!

## *Let Me Cater To You!*

In the beginning, God created a man named Adam. His primary responsibility was to till (work and manage) the ground in the Garden of Eden. Then, God took a rib from Adam and created "woman" so that Adam would not be alone and to serve as his [Adam's] helper. As marital tradition dictated, it was customary for men to work--be the "breadwinners"--and for women to stay home to nurture the children and be the homemakers. In the later part of the 1970's, single men and women broke the bonds of marital tradition by opting to "shack up" (couples living together without the covenant of marriage). Some women entered into relationships with men, commonly referred to as a "Sugar Daddies", whose exclusive purpose was to shower them with gifts and services. The Sugar Daddy's woman was deemed a "kept" woman. Sugar Daddies purchased furs, diamonds, and even sport cars to keep their women happy and at home. In the later part of the 20th century, due to women's lib, many women have risen up the corporate ladder and are now either competing with or exceeding the salaries once reserved solely for their male counterparts. With the surge of women in the workforce and the lack of single men, some women have become what I call, "Sugar Mamas" (women who exclusively provide for men while the men stay at home). Instead of "kept women" we now have "kept men". "Sugar Mamas" are women who try to buy "temporary bliss" without the attachments (marriage, lifetime commitment, dedication, etc.). Some call it a matter of convenience. I was acquainted with a "Sugar Mama" who would arise every morning to go to work, while her man stayed home and played video games all day. Yes, a grown man staying home and playing video games! When she left for work, he was playing video games and when she arrived home in the evening, he would still be

playing video games. What was the purpose of this unbalanced equation? Was it just to keep the loneliness blues away? On top of this, this woman had girls at home! What type of message was she sending to her girls? Did they disrespect her because she allowed this man to take advantage of her desperate need for companionship? Did it devalue their belief in the covenant of marriage while promoting "shacking up"? More importantly, how did she feel about herself? Was she settling for second best or less because she thought that this all she was worth?

One morning while listening to my favorite morning radio talk show, a woman sent in a letter to the write-in segment that stated that she had been living with a particular man for several years. During that time, she had contracted multiple sexual transmitted diseases (STDs) from him. Each time, he would apologize and then they resumed their relationship with unprotected sex. In discussing this with her so called friends, their viewpoint was that at least she had a man. Now, here she was seeking the advice of a radio personality, who advised her and validated what she knew in her heart to be the answer--vacate this senseless and useless relationship. Clearly, she has physical evidence that this man is not committed to her exclusively nor does he value her physical well-being. He blatantly showed his disrespect for her; he is deceitful, insensitive, self-centered, callous, distrustful, and dangerous. Hypothetically, the longer she stays with this man and continues to have unprotected sex with him, the more likely she is to one day contract a fatal disease that cannot be cured with penicillin. Once again, my question is what is the root cause of this woman's choice to remain in this physically debilitating and mentally demoralizing relationship for so long? Is it the same characteristic that prohibits a woman from leaving a man who domestically and sexually abuses her? I am inclined to believe that if both of these women (both of whom are victims) took an assessment and self-examination of their lives, they both would end up on the doorstep of low self-esteem. Low self-esteem will permit you to sign your own death warrant. Ladies, it is unnatural for you to completely center your life around someone who

is not centered around you! A man who is centered around you will form a partnership with you. He will not "suck you silly" or "drain you dry". He will provide for you, protect you, and put your well-being above his. I am friends with a wonderful couple, and I am going to mention their names because I love and respect them so much, John and Carmen Dorsey, who absolutely epitomize what a loving marriage should exemplify. I have heard John say on more than one occasion that he would give his life for his wife, and I believe it, because he treats her that way.

Ladies, this is why I have made a conscientious decision to position myself and wait for a man who expresses that exact sentiment for me. I am posturing myself to wait for a man who is positioned to be the "provider" and I am positioning myself to be his "helper". Why? Because I know that I am worth it! Also, because I know that this kind of love exists, thanks to my friends, the Dorseys.

Let me interject, that I do not have a problem with a woman earning more money than her spouse, if the both of them know how to manage the mental and physical responsibilities and challenges. I know that one day that I will be a multi-millionaire with multiples stream of income. I do not expect my husband to necessarily match my income level (but if he does, I certainly would embrace it [smile]); however, I do expect him to be an integral part of what I do. For instance, I am the playwright and he is the producer. He could handle the business aspect and I could handle the creative aspect, which I am more comfortable with anyway. However, I will not accept the scenario where I am on the road constantly producing and directing plays and he is at home watching television, fishing, and playing golf. No! No! No! He has to occupy the position for which he was created – the provider. He has to be the king of the castle and I will gladly occupy the position as the queen. In fact, I look forward to the day that my king will come and occupy his place on the throne. Yes, at time I desire companionship, but my desire for compatibility supersedes my desire to cohabitate with a man to whom I have to put forth ninety percent of the effort while he yields only ten

percent. He wants to be catered to but does not want to be the caterer. He wants to drink the milk and eat the beef without purchasing the cow! Let me make it plain, he wants to sleep with you and have free access to you, but he does not want to permanently make you his "boo" (his wife).

In conclusion, I would like to say--ladies, stop handicapping these men by prohibiting them from being the men that they were intended to be, spiritually and naturally. Occupy the role you were created and destined to be and let him do the same. The Creator of the Universe clearly outlines the family model in Ephesians 5:21-25 and 33, which starts with submission to one another - it takes compromise and "give and take" in a relationship by both parties:

*21) Submitting yourselves one to another in the fear of God.*

*22) Wives submit yourselves unto your own husbands, as unto the Lord.*

*23) For the husband is the <u>head of the wife</u>, even as Christ is the head of the church, and He is the Savior of the body.*

*24) Therefore, as the church is the subject unto Christ, so let the wives be to their own husbands <u>in</u> <u>everything</u>.*

*25) Husbands love your wives, even as Christ loved the church, <u>and gave himself for it</u>.*

*<u>33) Nevertheless, let everyone of you in</u> <u>particularly so love his wife even as himself; and</u> <u>the wife see that she reverence her husband</u>.*

Sugar Mamas, let him pull his own weight in the relationship. If he truly loves you, he will "fall head over heels" in love with you, propose to you, and marry you! There is NOTHING that he would withhold from you!

Some may say that I am being "old-fashioned"; however, I call it being fashionable, stylish, sophisticated, and smart. I am dressed for the journey; what about you?

# THE LAW OF RECIPROCITY
## (Balancing The Scales)

*"Give, and it will be given to you...."*

The Law of Reciprocity means: "to give and take mutually; to return in kind or even in another kind or degree." [22] Simplistically, whatever you give should be returned to you in one form or another. Ladies, have you ever been in a relationship where you were giving all the love that you could muster but you were not getting love in return? You initiated the communication (via e-mail, telephone calls, text messages, or greeting cards) and/or you initiated the dating (you made the reservations, and even paid for dinner and the movie). As Janet Jackson asked, "What has he done for you lately?" The art of love and relationship between a man and a woman is a mutual experience. If one partner is always the recipient and never the giver, it may be evidence that the commitment is not shared; lopsided relationships only lead to frustration and discontentment.

When a man is into you, he will call you at bedtime and fall asleep listening to your voice. He will send you flowers, for no reason at all. He will watch "your favorite love story" even though he would rather be watching an action-packed "shoot-em-up". Percy Sledge really drives the point home in his song, *"When A Man Loves A Woman"*. The lyrics are:

*When a man loves a woman*
*Can't keep his mind on nothing else*
*He'll trade the world*
*For the good thing he's found*
*If she's bad he can't see it*
*She can do no wrong*
*Turn his back on his best friend*
*If he put her down*

112

*When a man loves a woman*
*Spend his very last dime*
*Tryin' to hold on to what he needs*
*He'd give up all his comfort*
*Sleep out in the rain*
*If she said that's the way it ought to be.........* [23]

When a man loves a woman, he does not leave you guessing – you know that he loves you!  He is interested in what interests you.  When you are sad, he is there to listen and offer a hug for comfort.  He will even rub your feet at the end of a long, hard day!

When a man loves a woman, he has nothing to hide – you know his friends, co-workers, and his family.  Beware ladies, if your dating moments are **ALWAYS** spent in cities other than where you reside, or alone in dark, secluded areas avoiding the company of others.  Take precaution, when you call his cell phone and it immediately goes to voicemail on the first ring and you do not receive a return call for several days.  Especially take heed, when he pretends that he did not get the message you left and leaves the impression that it was never delivered.

Listen to me intently ladies, if you have to spend one minute wondering and pondering if a man is interested in you - then he is not!  An interested man will not leave you guessing!  Men are physical creatures and will always send some type of signal to inform you that they are interested – a smile, a wink, a request for a number or a second date.  If you go out on a date with him and then you do not hear from him for several days (unless there was an emergency) – do not waste your time – he is not interested.  A friend of mine called me today and told me she had re-united with someone in her past and happily revealed how this gentleman calls her every day just to see how her day went and to say good night.  That is a man who is interested in a woman!  Ladies, it has been four years since my divorce from my second husband and admittedly, dating in this 21st century is so much different than it was when I was a

teenager back in the 20th century. It appears to me that good old fashioned courting and chivalry are things of the past. I remember when I was 15 years old and my mother decided that I could "keep company" (through the persuasion of my father). My boyfriend and I sat in the family room on the sofa and my mother sat in the chair next to us and chaperoned. I forgot to mention that in order for us to "keep company" he had to ask my parents for permission, first. Back then, there was a respect level and dating rules between boys and girls that seem to be forgotten today. Then, a boy would go to great lengths to show his love and affection for that special girl.

Since my divorce, I have briefly dated (if you could call it that) three men and each of these men had fear of commitment issues that prevented them from exploring the possibility of establishing a relationship. Each of them is still carrying some residues of their past marriages and refuses to open up, as they say, "to just one woman"! I, on the other hand, refuse to be a part of a smorgasbord in which a man is trying to explore his options in life, nor am I willing to put forth my resources and time for someone who is afraid to put forth theirs. Therefore ladies, we have a stalemate. During a recent discussion, a single female relayed to me that in the Washington, DC metropolitan area (in which I reside) the ratio of single man to woman is seven women to one man. What is REALLY going on? What happened to the days of old when the men shared their sentiments as the group, *Heatwave* expressed in the song , "Always and Forever"?

*Always and forever*
*Each moment with you*
*Is just like a dream to me*
*That somehow came true*

*And I know tomorrow*
*Will still be the same*

*Cause we've got a life of love*
*That won't ever change and...* [24]

And the women answered with Etta James' *At Last*:
*"At last*
*my love has come along*
*my lonely days are over*
*and life is like a song*

*I found a dream*
*that I could speak to*
*A dream that I*
*can call my own"* [25]

And so this is how the Law of Reciprocity goes--you give love; and I give love; and we both receive love together. As you may perceive, I am a romanticist, who believes in the expression of love. What good is affection unless it is shared? So ladies, I conclude by saying when you give love make sure it is reciprocated. Give and it shall me give unto you--sow good seeds and reap the benefits. A true testament of love is when it is returned unto you. Experience the Law of Reciprocity. Anticipate the journey...

## SOLITARY CONFINEMENT
## (Married Yet Alone!)

*Silence creates a "mudslide" that puts a crack in the rock solid structure of your marriage; it puts "asunder"! Vickie L. Evans*

Marriage – members of the opposite sex, merging together with singleness of purpose – harmoniously sharing the same namesake and dwelling place. Marriage -- a place of conception where dynasties and empires are born, producing little descendants to carry on the family legacy for generations to come. Marriage--a corporate merger – the intermingling of ideas, goals, dreams, and resources; the formulation of intellectual proprietorship! Marriage--the sharing of intimacy; the fulfillment of sexual ecstasy and pleasure; the consummate rhythm of two bodies creating a melodious symphony of love! The Bible even describes it as "two flesh, becoming one", "bone of my bone", and "flesh of my flesh".

If marriage signifies a bond of unity and intimacy, how is it possible for married couples to live under the same roof and yet be so far apart? How is it possible for married couples to sleep in separate bedrooms, denying the sexual intimacy that makes love burst with excitement? How is it possible for two people who confessed their undying love before God and loved ones to walk around for days on end after a heated argument without speaking to one another? What causes a love that once sizzled, dazzled, and created a spark of "fire and desire" to fizzle in a heap of cold ashes? What happens when the only communication between husband and wife is the closing of doors as they exit for their various workplaces in the morning, and as they return to retreat into their separate sleeping quarters in the evening? What happens when marriage becomes a matter of convenience based on salary assessments and material investments?

What transpires when parents stay together for the sake of
the children but forget the intimacy once shared to create
the children?   How did the joyful expression of love and
marital bliss become encased in a wall of stone cold silence?
What occurs when marriage seems more like a prison
sentence carried out in the solitary confinement of a dark,
isolated, and cemented penitentiary cell?  Can anyone
relate?  I spent many hours trying to figure this out as I
gripped my tear-soaked pillow in the middle of the night as
my then husband slept in the basement of our house.  I
agonized over what I could have done differently to make
his heart turn back to me.  Right now I hear an Earth, Wind,
and Fire song  *"After The Love Is Gone"* ringing in my ear.
*After The Love Is Gone! What used to be right is wrong!*
*Can love which is lost be found? Something happened*
*along the way, what used to be happy is sad!"*  And then
my most favorite balladeer, the late great Luther Vandross
penned a song entitled *"A House Is Not A Home"* that said:
*"A room is still a room, even when there's nothin' there but*
*gloom. But a room is not a house and a house is not a*
*home; when the two of us are far apart. And one of us has*
*a broken heart."*  Obviously, these songwriters, at some
point of their lives, experienced solitary confinement, also.

Solitary confinement stems from the lost of communication
in a marriage.  Once the communication is lost, then the
other elements of marriage (trust, respect, intimacy, etc.)
begin to die also!  Solitary confinement in a marriage can
only lead to "a broken heart".

Ladies, when it comes to a marriage, "silence is not golden"
in fact it is a deadly killer to the cohesiveness of your
relationship. ***Silence creates a "mudslide" that puts***
***a crack in the rock solid structure of your***
***marriage; it puts "asunder"!***  I often wondered about
the meaning of the statement that the preacher says at the
end of a marriage ceremony, "What God has joined
together; let no man put asunder!"   It was unclear to me
what the word "asunder" meant.  Upon research, it simple
means "to tear apart".  That is the effect of silence/the lack
of communication; it tears a marriage apart.  Subsequently,

it is sad when you are the man or woman who put your own marriage "asunder".

The root cause of silence in a marriage is pride, stubbornness, and selfishness. No one wants to take the blame for whatever situation caused the disruption of communication. But I want you to know that the "blame game" does not work when it comes to relationships. In my opinion, taking the blame does not render you inferior; in fact it makes you the bigger person. Why not take the blame for the fact that you are having a misunderstanding, or take the blame for the sake of saving the marriage? What is more important being right or being united?

Wow, all of this is coming from a person who relishes being right and will go out of my way to prove a point. But a wise person once told me to pick and choose your battles, some are not worth fighting. Furthermore, the Bible states in Proverbs 14:1, *"Every wise woman builds her house but a foolish woman tears it down with her own hands."* Ladies, consider the outcome; will the winning be worth it? Will it promote strong relationships or will it derail it? In some cases, if you pursue your own righteousness; there are no winners; even the winner loses! (Ponder that!)

Now, I must interject that there are some cases that are beyond your control and the silence and break down of communication is generated from an external source. Therefore, no matter what course of action you initiate – you cannot fix the erosion of the marriage. For instance, my ex-husband was having an extramarital affair and his silence was due to the fact that his heart was somewhere else. As the O'Jays so plainly summed it up, *"Your body's here with me but your mind is on the other side of town, you're messin' me around."* At this point, the "asunder" ball is in his court because he has broken the marriage covenant and now adultery has cracked the liberty bell of unity. In this case, do not take ownership for **his** immoral behavior; it is not your fault and do not let anyone try to shift the "blame game" to your side of the fence.

118

There is nothing like a dose of infidelity to deliver a blow to your self-esteem. It (infidelity) sends your emotional rollercoaster colliding into avalanches of confusions and spiraling down into valleys of resentment. Some days you are walking a tight rope – the tension is so fierce and you feel that you are doing a balancing act on the edge of a cliff. One day you are angry and the next you are sorrowful. Another day you are shooting bullets of bitterness, while the next day you are drowning in the sea of depression. At some point you begin to look for a reason or reasons to blame yourself for this breach in covenant. You question you womanhood and your sexuality. Your mate may take this occasion to shift the blame off of him by taking you on an unmerited "guilt trip" with statements like: "You are not a good housekeeper!" (This appeared to be the number one "blame caster" on my favorite television judge show, *Divorce Court.*) Or, "If you were handling your business (in the bedroom), then I would not have to go elsewhere!" Or simply, "You changed after we got married!" This is what Psalm 36:2-4 has to say about his unmerited actions:

*2) For in his own eyes he flatters himself*
  *too much to detect or hate his sin.*

*3) The words of his mouth are wicked and deceitful;*
  *he has ceased to be wise and to do good.*

*4) Even on his bed he plots evil;*
  *he commits himself to a sinful course*
  *and does not reject what is wrong.*

Once again, I caution you, do not let him make you feel guilty for the division he created by tearing apart (putting asunder) and breaking spiritual covenant with you and God by illegally joining himself with an outside force, placing the marriage in a state of solitary confinement.

In conclusion, I believe that if your marriage is in the early stages of "solitary confinement", it may be salvageable; seek counseling right away!  Make sure the counselor is spiritually-sound and he/she understands that you are in crisis mode and need prompt assistance. Restore the breach; make every effort to "turn this house back into a home"; honor the marriage vows; and "let no man put asunder!"  "United we stand, divided we fall!"  Let us journey on, together...!

# I AM THE OTHER WOMAN!
## (Overcoming The Shame Of Infidelity)

*"He that is without sin among you, let him first cast a stone at her." [John 8:7 KJV]*

This chapter, by far, is the hardest for me to write because I am going to divulge some very personal situations; yet, I believe it is necessary. As far as my memory serves me, in every church I have been a member, there has always been a Women's department. From the Purity Group, to the Daughters of Destiny, to the Ruth's Circle, whatever the name - the topics remained the same. Women gathered together to discuss how women should act, dress, be submissive, and the list goes on and on.

The instructors consisted of widowed women who had a "set" mentality; or wholesome married women who have been married to the same man since their teenage years – their first and only love; which I applaud. Some of the instructors gave keen and comprehensive relationship instructions on what you should do to "get a mate"; how you should wait until "God" sends your mate; and the manner in which you should conduct yourself in the meantime – as chaste women. Undoubtedly, this is very sound teaching for the category of "good girls" who have been saved, sanctified, and in the church all of their lives. In retrospect, my life has been in sharp contrast and I am sure there is a quorum of you who could share my testimony in some aspect. I cannot say that I have only been with one man nor can I speak from the perspective of being married to just one man. Just once, I wish that someone would give me the opportunity to teach the women's class to impart a glimmer of hope to those who

121

have "messed up", yet have been redeemed, forgiven, and restored by the mercy of Jesus, like myself!

I am not a woman who has lived a "squeaky clean" life. I have experienced the heartbreak of cheating and infidelity as far as I can remember; beginning with my high school boyfriend, to whom I gave my virginity as a Christmas present at the age of 15. He gave me a promise ring and pledged his undying love for me and since I had not purchased a tangible gift for him; I gave him my virginity. After all, he promised to be with me FOREVER. Now, some of you may be reading this in disbelief, while shaking your head and saying, "Boy, she sure was naive!" But to a tall, skinny, girl who felt very unattractive, and who measured her worth by the love of others – this was the best gift a boy could give a girl – a diamond promise ring! In my eyes, this was the first step to an engagement ring. Huh, imagine the pain I felt when I received a call from my best friend telling me that this person, who promised to love me forever, cheated on me with a girl that I classified as one of the prettiest girls in our town – with her long, wavy, hair; high yellow complexion; and coke-bottled figure. She was the very girl who openly declared that she would never date him because she thought he was ugly. How could he betray me after I gave him my most precious gift – my gold nugget virginity? Needless to say, my self-esteem was at an all-time low! That was my first taste of gut-wrenching heartbreak. My trust in the opposite sex plummeted and his unfaithfulness became the measuring stick for every man I encountered thereafter. I know most people consider a "first love" - "puppy love" but "puppy love" is real to a puppy.

Let us fast forward into my adulthood. On a cold November night, I met "Mr." tall, dark, and handsome in a crowded night club. I was not looking for him but he found me – although there was not an instant attraction on my part. Let me say something here that is a very important factor to this story. When, I met this man,

who later became my husband, he had a girlfriend in another state. Needless to say, he was not loyal to her because in a very short period of time, we began a relationship. My point is that if he was not loyal when I met him, how in the world did I fool myself into thinking that he would be loyal to me throughout our marriage? I did not have any integrity either, because although I did not know his girlfriend, I should have had enough compassion to say "no", because I knew what it felt like to be hurt by someone you love-- "my first love". But hindsight is 20/20 and when you are young and full of hormones, you do not rationalize such things.

At the age of 18, I was quite impressionable; therefore, to meet and date a military man with his own car and apartment was quite a "feather in my cap"! For this man to pursue me, propose to me on Valentine's Day, and to marry me within six months were very significant events in my life.

Initially, our lives seemed very happy - we had a beautiful daughter and everything seemed fine. We lived in Schwabisch Hall, West Germany, his first over sea's assignment in our quaint apartment; just the three of us. There, is where I had my first suspicion of him having an affair – a suspicion that I could not confirm. There was a rumor circulating about him and a young married lady (who incidentally was a member of my church), who he danced with at a party, in an intimate way. When I questioned him about his rumored indiscretion; he denied it. He was big on saying to me, "Prove It!" and since I could not, I left it alone. However, I did not have to prove my second suspicion, because it revealed itself (or should I say she revealed herself) right in front of my eyes. To my surprise, he had an affair with one of my co-workers! One evening when he came to pick me up from work, I saw the two of them making eye contact. Some of the other co-workers, who knew about the affair, burst out in laughter when they saw me. Instantly, I knew and

he could no longer pull the wool over my eyes!   What a hurtful, humiliating, and heart-wrenching discovery!

Though it took some time to recover from the pain, I did forgive him, mainly because I did not want to break up our family, which had expanded from one to three children. My religious teachings also instructed me that divorce was wrong; yet, no one told me that when a man commits adultery, he has broken the marriage covenant – so why remain loyal to disloyalty?  Each time he violated our marriage; he chiseled away another part of my self-esteem and drove a wedge of unworthiness into my heart.  I know how it feels to be violated, disrespected, dishonored, and humiliated not only by my husband, but by the women in which he was involved. These merciless women flaunted the fact that they were involved with someone else's husband.  They were not concerned with the possibility of aiding in wrecking and breaking up our family.  In fact, they would brag about it by foolishness saying, "Well, if she was taking care of home, then maybe he would not be with me!"  Not realizing that he was using her as well, and that his intent was to "have his cake and eat it too!"   Once, a friend of one of my husband's lover once instructed me to get a man of my own.  Imagine that, this was MY husband and I was supposed to get a man of MY own!  In most cases, these cheating husbands have no intention of leaving home – at least mine did not.  Hold on a minute, do not sympathize with me yet; wait until you hear the "conclusion to this whole matter"!

Ladies, how many of you know that if you kick a dog too long, eventually he will bite?  This is not a fact that I am bragging about because for so many years I carried the guilt and shame of the transgressions that I am about to reveal.  One night after suffering verbal abuse from my husband, I decided I was not taking anymore infidelity and at that point I decided that "two could play that game".  Yes, I had an affair!  I want to remind you that a few months after my first husband and I married, I gave

my life to Christ. So the next few exploits that I am about to confess occurred while I professed salvation (a born again Christian), and at one point, after my call to ministry. The very thing that I despised; I became – an adulteress!

One night in my despondency, I went out looking for "something new" to comfort me, and found him. It is indeed a true statement, "If you go out looking for "Trouble"; eventually, you will find it; or in this case, Him!" He (Trouble) was everything I wanted in a man -- handsome, successful, attentive to my needs, adventurous, athletic, romantic, a good communicator, and a good listener. I like to interject at this point, that now that I am older and wiser, I realize that I did not have the mental capacity to make sound judgment concerning what was "right" for me because I was hurting, rejected, despondent, confused, disillusioned, and very disappointed. I later found out the hard way that what appeared to be good – was only temporary and counterfeit; and eventually I set myself up for more hurt and pain.

When I first met "Trouble", he was single and I was the one who was still married. However, since my marriage was already problematic and since my husband had other interests, it was easy to spend more time with "Trouble" and I justified it because he made me happy. The first six months were like a whirlwind romance, he shared my love for theater and I shared his love for athletics. In fact, I became his personal cheerleader at each one of his sporting events. We dined at the finest restaurants and lodged at the finest hotels. Holidays like Valentine's Day and Christmas were quite memorable – he bought me exquisite gifts for both. We were inseparable except for his occasional Amway meetings or golf weekend with the "boys". And then one evening my world came crashing down and my "fairy tale" romance turned into a "horror flick". This particular evening, "Trouble" was scheduled to attend an Amway meeting

and he told me that he would probably be home very late. For some reason, I could not rest that night, so I decided to take a chance and surprise him by coming over after the meeting, although it was late. Though I called him several times and did not receive an answer, I drove over to his house anyway. To my surprise, his truck was home. I assumed that he had just arrived home; so, I knocked on the door. And I knocked again, and again; but there was no answer! Then, I knocked on his bedroom window, called his name, and requested that he open the door. I went back to the door and knocked again. Finally, he answered. However, instead of the warm greeting that I usually received, he stood there sternly and said that "this was not a good time!" That statement caught me off guard, (anyone that knows me can guess what I did next) so I persistently asked him why was it not a good time? As he tried to hurriedly turn me away, a young lady dressed in his t-shirt and boxer shorts appeared from behind him and inquired who I was. I asked her who she was (as if I had ownership on this man) and she replied, "His fiancé!", and then she held out her ring finger to showcase her beautiful diamond engagement ring. I felt as if a bolt of lightning had struck me from the top of my head to the sole of my feet. That day, I vowed never to see him again. I wish I could tell you that this is how the story ended, but it is not! Though I ignored his calls and I avoided seeing him, he would not leave me alone. The more I rejected him, the more he pursued. Eventually, my defenses collapsed and we resumed our relationship. Here is the most shameful part of the story. Did he marry her? Yes, he did; yet, our relationship continued! He even called me on his honeymoon night. A week later, she called me after she received the phone bill and noticed that he called me on his honeymoon night. I repeat--the very thing that I despised; I became! A cold, thoughtless, insensitive, and relentless adulteress! My! My! My! Oh what pain I brought this woman; yet at the time I did not care, all I cared about was my own self-satisfaction, and the time he spent with me. At one point, she even

separated from him, but I guess he pursued her as he did me, and they reconciled. Finally, the cycle of deception, cheating, and infidelity was broken after being separated from him by distance due to his career relocation. Then, the demons of guilt, shame, and regret became a thorn in my flesh until I surrendered my will and finally repented and asked God to forgive me for my transgressions. Gratefully, God did forgive me, but not without chastisement. I lost some things due to my insurrections. I lost something very valuable to me and I have yet to recover it; I am not sure if I will ever. The price I paid for a "frivolous fling" was not worth the lost I experienced and the self-loathe that I felt almost cost my life; I went into a deep depression and even entertained thoughts of suicide.

If justice had prevailed, I would certainly be worthy of being stoned. I thank God for being "A God of Many Undeserved Chances!" Since my day of atonement – I have not nor will I ever put myself in a position like that again. I will not disappoint the Father in that manner EVER and I do mean "NEVER EVER!" I felt like He looked at me from a distance with tears in his eyes and questioned whether His Son's dying was in vain. I could imagine how hard it was for Him to even cast His eyes on me; how I betrayed Him. If you have ever been in a position when you know that you displeased the Father and you imagined the pain it caused Him, you can relate to how I felt. I felt worthless, like the scum of the earth, cruddy, and grimy. Jesus paid the most valuable price of all for me - His Life; what more could anyone give? Yet through my sinister need to satisfy my flesh; I crucified Him afresh – it was me who pierced him in His Side, drove the spikes through His Hands and Feet – again! I covered my face in shame! I do not ever want to jeopardize my inheritance over a "cheap fling" again. I rather live alone than to lose the Love of My Life.

If I had the opportunity to say "I'm sorry" to that woman, whose marriage and self-esteem I disavowed and

disintegrated, I would humbly bow at her feet and wash her feet with my tears. I carried the guilt and shame of my misconduct for many years until The Father said to me one day; "You have paid the price, so let it go!" If any of you who are reading this book are currently or have previously suffered the shame of infidelity; know that all is not lost. He is A God of Another Chance! He can "Make Us Over "Again" and "Again". Like clay on a Potter's wheel, he can mold, us, make us, and re-shape us again! The singer Tonex said it best in his song, "Make Me Over Again":

**You Know My Other Side,**
**I Can No Longer Hide**
**Let You Down So Many Times**
**Sin Freshly Crucifies**
**Thought That I Had A Plan**
**I Had It All Figured Out,**
**But The More That You Tried, To Be My Side**
**The More I Pushed You Out.**
**(CHORUS)**
**Lord Make Me Over**
**Make Me Over Again Lord**
**Time After Time I Failed You**
**Pierced Your Side When They Already Nailed**
**You**
**Jesus Healed My Open Wound**
**I Just Want To Be More Like You**
**Make Me Over Again!**

I am so glad that God does not keep a record of my wrongs and He has imposed measures and provisions for me to repent and be restored. I am equally glad that my worth and value is not rated or determined by my past successes and/or failures because the wrong that I had done would probably eliminate me for receiving a position of honor in the kingdom of God. I love the parable in St. John 8: 4-11, about the woman who was caught in very act of adultery, who the men brought before Jesus to confirm that she should be stoned. Jesus

did not even look up; he just continued to write in the dirt. When He did not reply, they asked Him again. He then responded, "Ye without sins, cast the first stone!" One by one, her accusers (from the eldest to the least) departed. He asked her if any man had condemned her. She said, "No!" He then replied, "Neither will I!", and He told her to go and sin no more! She was no longer "the other woman", she was a new woman and so am I. Romans 8:1 clearly states that *"Therefore [there is] now no condemnation (no adjudging guilt of wrong) for those who are in Christ Jesus, who live [and] walk not after the dictates of the flesh, but after the dictates of the Spirit* **(Amplified Bible)."** No more shame, no more guilt! Woman, thou art loose! Come out of the grave! Take off the grave clothes! Go, and sin no more! You have been bought with a price! Renew yourself for the journey!

## THE PARENT PAUSE
## (Confessing Our Mistakes!)

*"What about the children, to ignore is so easy..?"*
*Yolanda Adams*

I would like to start this chapter out by immediately apologizing to my three children for the "off the mark" parenting methods I used and choices that I made out of ignorance that may have caused them hurt and pain. In my defense, I would like to say that I have not encountered or read any foolproof parenting manuals and guidebooks, which can effectively teach a parent how to raise their children. Inadvertently, I did the best I could with the tools that I had. Ladies, you could read Dr. Spock's books cover to cover, but I would bet that they would not be a foolproof or exclusive reference to effectively aid in the raising of your children.

Subsequently, each one of my children is unique, with their own distinct characteristics. I have one who punches trouble in the nose and dares him to fight back. And then there is the one who is the oldest by birth but in the middle of the road by personality—she is mild-mannered; yet, she can be very feisty—according to the circumstances. The last one, "Baby Boy", does not say much; but if trouble pushes his button, he (Trouble) will regret it because an explosion is on the way. Since they are different, different methodologies are needed to deal with them. I made the mistake of trying to deal with them in the same manner – doling out the same disciplinary actions and imposing global punishments. I repent – I was wrong.

How many of you have said, "I will never be like my parents", but find yourself acting the same way, and saying some of the same things that your parents said? Truthfully, parenting is learned behavior; we are the products of our environments. Inadvertently, we use some of the same

methods to raise our children that our parents used on us. Some of the methods that our parents used were adapted and adopted from their parents and so on and so on. Some methods were good and effective and some were not. For instance, I have a son whose birthday occurred immediately after the school term began, and since his grades were not as suitable as they should have been; he usually was on punishment during his birthday. One year, we bought him toys, showed them to him, and then put the toys away until he improved his grades, which did not happen. This "now you see it; now you don't" routine is a hard pill to swallow for a child. As a result, he developed a negative complex/omen that something bad always happened on his birthday. He carried this omen into his adulthood and created situations, through his fear, which validated his theory. Because he emitted negative energy into the atmosphere with his derogatory thinking concerning his birthday; something bad would really happen on his birthday. One year, he even secluded himself in his room on his birthday in fear of something bad occurring. In hindsight, what could we as parents have done different? Since the punishment alternative was not working, it probably would have been wise to try a more workable solution. Well, instead of punishment, we could have taken the money that we used to buy toys, to enroll him in some type of after school program that would have given him extra assistance with his schoolwork, since he obviously was having learning challenges each year. Instead of finding a solution, we created bigger and longer-lasting problems-- fear and the establishment of a perception of an omen. To our son, I apologize! In our eyesight, we believed that we were doing the right thing.

Parents, just as we can look back on our lives and see incidents that caused low self-esteem in us, we inadvertently may have evoked low self-esteem in our children, also. It has been said that "hurting people--hurt people"! But, it is never too late to enforce corrective measures to break the cycle of low self-esteem, starting with admitting our wrong. Do not allow them to continue to believe that the poor choices we made were right; therefore,

causing them to continue the practice of transference and erroneously using these methods on their children. Destroy the yoke now!

Culturally speaking, spanking has been a primary disciplinary action in the African American race. I still do not have a problem with spanking as long as it is not administered in anger. Some of the acts that we as parents classified as spanking cannot be classified as such – it was more of a "beating". Whelps, scars, bruises, and even the drawing of blood were evidence of our angry outbursts. Saying, "My parents whipped me and I turned out O.K.!" is not justification for our abusive nature. At some point, we simply must say, "I apologize!"

I became a parent when I was 19-years old. At that point in my life, I had barely entered adulthood and did not have a clue on how to make constructive decisions concerning my own life, let alone making effective parenting decisions for my child. I was still growing and learning! Therefore, I readily admit that I may have been ill-prepared to become a parent. Unfortunately, this is a fact that I cannot change – it happened. But, since I am older and wiser, I will try my best to be the best parent I can be, and I hope and pray that I can help you on your journey on becoming the best parent you can be, also.

Now, I have to interrupt this parenting session with a newsflash. I have just had a startling discovery that quantifies and validates everything that I have said here! Today, during my moment of leisure, I watched a television judge show called *Judge Mathis*. This episode depicted a mother who was suing her 18-year old son because he promised to pay her for bailing him out of jail, after he was arrested for selling Crack cocaine. She starts out by stating that she wanted her son to take "responsibility for his actions" and pay back what he promised.

When Judge Mathis began to question the son concerning his actions, he stated that for eighteen years of his life (remember he is only eighteen – so that is all of his life), his

mother was addicted to Crack, and she (the mother) admitted that she had been in rehab for only forty-five days. In fact, he eventually became her supplier. He dropped out of school at the age of 15 because he felt "he had to support his younger brother" because his mother was not! Before dropping out of school, he was doing quite well academically, making "A's" and "B's". Now, he is being schooled in drug selling and street survival. I also have a cousin who has a similar story, who was living inside of abandoned houses with his younger brother and shoplifting to feed him due to a "Crack-addicted" mother. Anyway, Judge Mathis began asking him other questions to see if the son had a reasonable explanation for his "lack of responsibility" as accused by his mother. Judge Mathis asked him was he selling drugs because his peers did it and he replied, "No, my "boys" (male friends in the neighborhood) actually helped me!" When Judge Mathis inquired how, the young man replied, "They took me in when I did not have a place to stay and oftentimes they fed me when I was hungry!" Then, Judge Mathis asked him, "Why didn't you find work at a fast food restaurant? He replied, "I submitted applications but was not hired because I don't have a high school education and now fast food restaurants require you to have a high school diploma or a GED." Next, Judge Mathis asked the young man if there was a male role model in whom he could have sought counsel. And the young man replied, "The only male role model that I ever had went to prison." Judge Mathis asked, "What about Social Services, why didn't you go to Social Services for assistance?" And the young man replied, "I did not want to get my mother in trouble, she still collects a check for me even now!" Eventually, Judge Mathis made this remark that give credence to the tears that welled up in my eyes and the pain that I felt in my chest, "This young man had no options because his parent was not responsible nor was she teaching him how to be responsible!"

Ladies, no child should be left without any options! Children should not be forced to operate in the role of an adult; they should not be the bread winner and supplier for the parent. Parents, we are failing our children and they are

angry about it. Some are prematurely assuming roles
without the necessary tools to operate and are learning to
survive by "any means necessary"! Children are raising
children which they did not birth (younger siblings)!
Songstress Yolanda Adams sung a song, *"What about the
children, to ignore is so easy!"* Parents, let us not continue
to ignore the problem; but let us strive to find solutions to
the problem. Granted, a solution may not happen
overnight, but let us tackle the issue one step at a time. Our
children are our future; unless we make amends, we will
lose them and they will really be called, "Generation X-
Terminated!"

If by chance, there is an awakening in your spirit and you
realize that because of your own insecurities and
vulnerabilities, you planted the seed of low self-esteem in
your off-springs, simply pause and ask for forgiveness!
You will be surprised how much pain a simple apology
can erase. Once the pain has been eliminated, fill the
void with positive affirmations and validations. Show
expressions of love in words and actions. Exalt and
exhort them! Tell them that you are proud of them! Tell
them they have Divine Purpose and Destiny! Tell them
that they are a blessing and not a curse. Let us raise up a
generation of intelligent warriors – "A Joshua
Generation", full of youth and vitality, that will take up
the mantle of where we, the "Moses Generation", the
ancestors of wisdom and counsel, left off.

Thank God for His Grace and Mercy that He has given us
time and opportunity to set the record straight. Once
you have freed your children, turn around and free
yourself. There is now therefore no more
condemnation....(Romans 8:1). You are free! And the
journey continues.....!

# LIVING LIFE WITHOUT REGRETS
## (Do Not Emulate Lot's Wife!)

One day at a time is enough... don't look back & grieve the past, its gone... don't be troubled about the future, it has not come yet... live in the present & make it so beautiful it will be worth remembering

26

Have you ever reflected back on some choices and decisions that you made or some things that you said and thought--if given an opportunity--you would certainly do things differently?  I know I have!   There are some things in my life I certainly would not repeat! Yet, when I look at the strength that I have gained through the things that I have suffered, and the wisdom that has been imparted in my life, I realize that even the bad times were good for me.  It took me a long time to make this statement and there are still times that I wish I did not have to go through certain things; yet, I am learning to "accept the things I cannot change" and to live life without regrets.

No matter how tumultuous, sporadic, topsy-turvy my life is some days; I am determined to stay the course of this

journey. Why? Because no one can beat me being me--I
will always win at that game! Also, I realize that God
created and predestined my life to be exactly the way it
is. He knew my shortcomings before they became
shortcomings. He was aware of the choices I would
make and the impending consequences of them. He has
given me assignments that I alone can tackle and
overcome. Every brand new day is full of unlimited
opportunity to achieve success and to prosper.

Nothing I have is indispensable. Everything I have lost
can be replaced, and that include relationships. Yes, I
have been acquainted with struggle and suffering, but I
survived and overcame it all. In fact, the trials and
tribulations that I have experience have made me
stronger, wiser, and oh so much better! I am determined
to live my life without regrets. There is nothing I can do
to change the past; the past is the past! Looking back
cannot increase or decrease my stature, nor is it a
measurement of my worth.

There is a popular Aesop's fable that I enjoyed reading as
a child entitled, *"The Tortoise and the Hare"*. The
tortoise, better known as a turtle, was a happy-go-lucky
sort-of- fella, who did not make a fuss about life—he
simply took one step and one day at a time.
(Coincidentally, "Turtle" was my childhood nickname
given to me by my Uncle Charles.) On the other hand,
the hare (rabbit) was always in a hurry; he had no time
to "smell the roses", the coffee, or anything else for that
matter. The hare was constantly bragging on how quick
he was and how he could beat any- and every- one. One
day the tortoise challenged the hare to engage in a race.
During the race, the hare ran up the hill, down the hill,
and around the bend at groundbreaking speed, while the
tortoise paced himself—breathing in the fresh air,
smelling the flowers, and enjoying the journey. The hare
sped past the tortoise, leaving a trail of dust. As he (the
hare) drew closer to the finished line, he decided to
pause and take a nap. He thought that the tortoise could

not possible catch up to him at this point. Meanwhile, the tortoise kept moving at a steady pace. He passed the hare as he was napping and continued towards the finish line. As the tortoise approached the finished line, the other animals, who were watching the race, began to cheer. (Note: There will always be spectators watching to see how you will make it to the next phase in your life.) The cheering woke up the hare from his nap. To his dismay, the tortoise was slowly crossing the finish line. He tried to hurry and catch him, but it was too late.

Ladies, it is not how you begin the race that matters; it is how you end it. King Solomon profoundly sums it up in Ecclesiastes 9:11: ***"I returned and saw under the sun that the race is not to the swift nor the battle to the strong, neither is bread to the wise nor riches to men of intelligence and understanding nor favor to men of skill; but time and chance happen to them all."*** Yes, "time and chance" happens to us all; none of us is exempt from life's trials and tribulations. Therefore, we must live life without regrets; keep your eyes on the prize, in order to cross the finish line and to successfully be declared the winner of the race.

Face it, we can NEVER retrieve the past--it no longer exists – it is now reclassified and called "a memory" – we can only gain access to it in our minds. The ancient treasures of our legacy now equates to archeological artifacts - *"any place where human activity occurred and where artifacts are found"*. We cannot press a "rewind" button and record it again. All we have in plain sight is today, the present, with hope and expectation for the future.

The Serenity Prayer makes a very noteworthy statement "Grant me the serenity to accept the things I cannot change". There are some events that have and will occur in our lives that we simply have no control over and are destined for our character building. When we regret,

(mourn the loss of something unchangeable), we unconsciously (and maybe unintentionally) declare that our sense of worth and value are tied to tangible things and temporal circumstances, instead of trusting and having faith in our Master and Creator. *While we look not at the things which are seen, but at the things which are not seen: for the things which are seen are <u>temporal</u>; but the things which are not seen are eternal* (2 Corinthians 4:18, [NIV]). Our expression of remorse send forth a multiplicity of negative vibrations that emanate guilt, shame, sadness, gloom, misery, stress, and distress which leads to a looming state of depression. We also signify mistrust in God's judgment and direction for our lives.

A very applicable biblical illustration highlights a woman whose life was cut short by a moment of regret, Lot's wife, referenced in Genesis, Chapter 19. Some readers, myself included, focus on the fact that she turned into a pillar of salt, which synonymously represented a posture of disgrace, but there are some other significant points that I previously overlooked.

The first point is that the destruction of Sodom and Gomorrah was an "unchangeable fact" and had been pre-determined and pre-discussed in Genesis, Chapter 18. In fact, Abraham dined with the male angels as they were in route to Sodom and Gomorrah to carry out this inevitable assignment. The Lord had a conversation with Abraham and revealed His plan to destroy Sodom and Gomorrah. Abraham made several pleas to spare the city and finally conceded because there were not even 10 righteous people found in it. The two male angels were actually sent to deliver Lot's family from destruction – they did not impose the sentence – God did. There are some situations that have been imposed in our lives to deliver us from the worldly and unrighteous acts that are in the path of destruction; yet, we buck against it not knowing that it is meant to save us and not destroy us.

The second point is that the male angels had to physically take "Lot and his family" by their hands to lead them out of the way of destruction; they initially resisted (Genesis 19:16). Ladies, have you ever been in a situation that was wrong, even dangerous; yet, because you had grown accustom to it; you refused to leave until you were forced out or taken by the hand and led out? Once delivered, as reality set in, and the blinders were lifted off your eyes, you realized that you had been living in hell--and now, through Divine Intervention, you are in a better place. As you can tell, I am speaking from experience! Although I had to be led out of my last divorce with resistance, and as painful as it was, today I am better off than I have EVER been. I am at peace and peace is a state of mind that I would not trade for all the tea in China. At this time, I would like to pause to apologize to and say thank you to all the angels assigned to me to deliver me out of adverse situations, who I rebelled against or met with resistance. Now, I know that you were simply carrying out the assignment sent from the Orchestrator of Life.

The third point concerns the Divine Instructions /Warnings (Genesis 19:16) that Lot's wife disobeyed, which cost her, her life. Those Instructions were: 1) Flee for your lives! 2) Do not look back! 3) Do not stop! When God sends warnings, it is best to make haste! Have you ever been in danger and did not know it, until the danger subsided? Sometimes, we are so attached to our circumstances that we are oblivious to what really is good or evil. For example, if I had married my high school sweetheart, as I had planned after my high school graduation, I would have been the wife of a drug dealer, who served multiple prison sentences. Who knows, I might be writing a different type of book right now or this chapter may have been entitled, "Living Life WITH Regrets!". But all praises to God, who knows what is best for me even when I do not; He moved me out of the area entirely (before my senior year in high school) to

prevent me from making a disaster out of my life.  For
the purpose of proving a point, I want you to PAUSE and
take a minute to reflect back to one situation in your past
that you are glad that things did not work out the way
that you desired.  Or, think about a situation when
danger did occur and you were headed towards it but
something (a phone call, an unexpected stop, you could
not find your keys, etc.) delayed you, and spared you
from the danger.  Stop right now and thank God for
sparing your life!

And the final significant point (which is actually two
points in one) is that that the city of Zoar, (which was
initially marked for destruction because it was a part of
the conglomerate of cities that included:  Pentapolis,
Sodom, Gomorrah, Admah, and Zeboim,  which made up
the providence of Sodom and Gomorrah) was spared
because Lot requested to reside there instead of fleeing
to the mountains.  Equally important, Sodom and
Gomorrah could not be destroyed until Lot's family was
safe and sound in Zoar.  Ladies, there are some people
(children, loved ones) who are spared from destruction
because of YOU.  That is why it is so important that you
recognize and know your worth and how valuable you
are to God!  Some of us could have easily been "Zoar" –
slated for destruction, and rightfully so because our lives
have been less than perfect--but because somebody
(Grandma, Mama, Uncle Abraham, etc.) prayed for us,
our very lives were spared.  I want to take it a step
further by declaring that some neighborhoods, regions,
and territories are blessed because we reside in them.

A few years ago, I lived in a housing complex that was
known for drug activity.  I discovered this fact after I
moved into the neighborhood.  I can emphatically state
that I did not experience or witness one problematic
incidence during the four years that I lived in that
neighborhood (other than the annoyance of having my
car towed for some ridiculous reasons).  My neighbors
were the nicest people and treated me with kindness and

respect. Our complex was quiet and free from loud activities and I never saw anything that could be classified as drug activity. The blessings of God resided in our neighborhood - His Hand of Protection was all around us because of my connection with the Father. My prayers (and a few other "prayer warriors" who probably lived there) covered that neighborhood.

Now, you can do the same by praying for someone else. And coupled with that thought is that the destruction of Sodom and Gomorrah was held back until Lot's family had reached their destiny – time stood still for them. God will make time stand still for you also! Do you believe it? I know some have faced some health challenges and the doctor declared that you would not make it through the night; yet, you are still here, and can testify that God will make time stand still for you. Lot and his family's lives were not spared based on their righteousness, but because of the righteousness of their Uncle Abraham-- "the effectual fervent prayer of the righteous availeth much" (See James 5:16). There is extraordinary power in prayer! Yes, God held back the hand of time until Lot and his family was safe and sound in Zoar. At the precise time they entered Zoar, "fire and brimstone" rained down on Sodom and Gomorrah. Think of some incident where you said, "That could have been me!" I have a friend who worked in one of the offices that was destroyed at the Pentagon during 9-1-1. Someone place a call--summoning her to a bogus meeting-- in which no one had any recollection, nor did anyone know who made the call. Because of Divine Intervention; my friend was spared from destruction. God has your back; therefore, there is no need for regrets.

The Bible reveals the end of Mrs. Lot story by pronouncing that she was turned into a "pillar of salt". The sad thing about Mrs. Lot's end is that she had already been delivered from destruction; however, even when the destruction was manifested and as fire and

brimstone consumed Sodom and Gomorrah; she still refused to let go of the past (Sodom). Some of you are there right now, your past is on fire—it is burned up—let it go baby, **LET IT GO**! The situation is destroying you both physically and mentally; yet you refuse to let go! You cannot embrace the blessings of God because you are holding on so tightly to a destructive past. The story of Lot's wife makes me appreciate the gift of Mercy. I can remember a time when God had delivered me from some adverse situations in my life which could have literally destroyed me, yet I looked back to the past as if I was better off while I was back there. This is similarly to what the children of Israel did when God delivered them from Israel; they said, "We were better off in Egypt!", though they were slaves in Egypt. I wholeheartedly understand the declaration made in Lamentations 3:22 --*"it is of the mercies of God that we are not consumed..."* It is because of His Mercy and Grace that I am not turned into a "pillar of salt", for I have indeed committed the act of disobedience like Lot's wife and "looked back" to situations in which I should have rapidly fled. Grace and Mercy gave me the opportunity to repent and be restored, unlike Lot's wife who lost her life and became a pillar of salt.

Therefore, I pay homage to "today" and I will not live my life with regrets, longing for "yesterday". I will not spend time thinking or reflecting on how life could have been; I am just happy to be me. I am happy for life abundantly. Angie Stone wrote a song that accurately sums up my sentiments entitled *Happy To Be Me*.

**"Stop reaching back from your beginnings
All those broken dreams that went down stream
As we grow, live and know
Some things were never meant to be
Just like people they come and go
Some will live forever and some will never know
That's why God gives us memories**

**To leave us to our victories**

**I'm so happy loving me!   So happy being me**
**I'm regretting nothing about me**
**Too busy Living life, Living love, Freely**
**So happy being me"**

It is time to "Forget Regrets"!  Know that the Lord
knows who and what is best for you and that He will
never take away something from you spitefully.  Please
realize that everything "works for the good for those who
are the called according to His Purpose", and "there is no
good thing that He will withhold from us"!  So, if He
sends someone to tell you to -flee for your life-, do not
look back, and do not stop; please, heed the warning!
Commence to running!  Living life without regrets is a
sure way to overcome low self-esteem and to avoid
depression.  Press forward to the mark of the high
calling.  Press forward at a steady pace, and complete the
journey!

# SELF-ESTEEM

# A GREAT CLOUD OF WITNESSES
## "A Tribute to the Women In My Life"

### 1. My Mother, Ruby W. Burrage

Wow, what a classy lady, my mother – Ruby Winfrey Burrage. She was my first example of what a "lady" exemplifies. As far back as I could remember, she always told me, "Vickie, act like a lady!" As a little girl, she dressed me like a "little lady" even with ruffled panties, and insisted that I did not get dirty. I even traveled with my own chair so that I could sit down and be "a lady".

My mother tried to shield me from life's "hard knocks" by making sacrifices beyond measures, even at the expense of her own happiness. Always wanting the best for me, she made choices to ensure that I would have an equal platform in life to obtain the best. She was adamant about me obtaining the best education. In the sixties, I was one of the first Blacks in my hometown (actually I believe I was the first) to attend an all-White elementary school, prior to integration, because my mother would not settle for me to

145

be taught with handed-down, used, and outdated school
material that was generally given to the all-Black schools,
(or should I say "Negro" as we were referred to then), after
the White students were finished using it.

Mom made me take piano lessons also, although I hated it
and did not understand why she was trying to introduce me
to classical music.  I remember how proud she was when I
performed my first piano recital.  It was a small piece
(similar to "Jimmy Cracked Corn" with just a couple of
notes) but you would have thought that I had just played
"Bach" or "Beethoven" by her smile and boasting.  For those
of you who are wondering if I currently play the piano, the
answer is "No"!  I quit soon after the recital but in
hindsight, I wish I had continued.  Who knows, I could have
been comparable to Alicia Keys without the singing – my
singing would make a pit bull howl.  My point is that my
mother has always been extremely proud of me.  If I
introduce myself to anyone in her social circles, usually the
response is, "So, you're Vickie, your mother talks about you
all the time!"

More importantly, she never allowed me to settle for less.
In fact, my humble beginnings in Sugar Land could have
classified us as "poor".  We lived in a pink, two room, wood-
frame house, located on what we called "Front Street".
There was a living room that also served as a bedroom, with
a bed for my parents, and a couch for me.  The adjoining
room was the kitchen which, upon mention, uploads a
horrific memory of me getting my hair fried and my ears
burned with a straightening comb.  We did not have an
indoor bathroom; instead we had an "outhouse".  The
"outhouse" was a wooden shack with a huge, dark, hole in
the middle of it, topped with a white lid of a commode.
Since I was frightened of the dark, my Dad would
accompany me to the "outhouse" at night to ensure that I
was safe.  Due to the lack of hot water, my mother would
boil water and pour it in a tin tub for me to take a bath
(sometimes on the front porch depending on the weather).
As I said, these humble beginnings could have classified us

as "poor" but my mother fashioned our lives in a way that I never even imagined that I was poor. In fact, I thought this was normal living with the exception of the "filthy rich" White people on the other side of the creek that divided the Whites from the Blacks in Sugar Land, who lived like June and Ward Cleaver on *Leave It to Beaver*.

Growing up, my mother was the glue that held our family together; it took me becoming a mother to appreciate her value. My mother would sacrifice our electric bill if she believed that I needed a new pair of shoes (of course someone in the neighborhood would use a wrench to turn the electricity back on – [smile]). I always had the finest of clothing. I cannot remember missing a meal or lacking anything for that matter. She taught me integrity and that I could do ANYTHING I set my heart to do. Even now, my mother calls me and asks me questions on subject matters about which I do not have a clue. When I tell her I do not have knowledge of what she is asking, she tells me "Sure you do; you know everything!" That is her way of saying you may not have the answer right now, but I know you are going to find it. She constantly challenges me to "stretch" my intellect and to gain more insight and understanding of various and complex topics. My survival skills were derived from my mother. She have faced some tough and horrendous challenges that should have swept her under current and drowned her; but after the strong winds ceased and the high tides subsided, she was standing tall like an oak tree in the midst of the tumultuous sea. Her most astounding trait is her ability to pray. She prays for me constantly. She taught me my first prayer; some of you probably know it also: *"Now I lay me down to sleep! I pray the Lord my soul to keep! If I should die before I wake! I pray the Lord my soul to take!"* That prayer covered me and carried me from my early childhood to my adulthood. My mother prays for me without ceasing. If it had not been for her prayers; I cannot imagine where I would be. There are times when I felt like I was drowning in the sea of trouble, but her prayers were my life vest. There were times when I felt as if I was sinking in quick

sand; yet her prayers pulled me out. She has been the "wind beneath my wings", undergirding me so that I would not let go! Mom, I may not always physically say "thank you" at every given moment, but I would like to stop right now and say "Thank You!" I am forever grateful.

A few years ago on Mother's Day, I wrote a poem that expressed how I feel about my mother entitled, "A Mother's Sacrifice":

### "A MOTHER'S SACRIFICE"

*Through Every Stage of My Life I Can See*
*How Much My Mother Sacrificed for Me*

*When I Was Only Six Months Old*
*She Shielded and Protected Me From The Cold*

*When I Began to Pull Up, Climb and Crawl*
*She Removed Every Obstacle, So That I Wouldn't Fall*

*When I First Spoke Her Name, Oh How She Smiled*
*"That's Me!", She Pointed and Proclaimed So Proud*

*As I Prepared to Take My First Step*
*She Stood Close By My Side In Case I Needed Help*

*The First Day of School Was Really Hard*
*It Was Tough To Let Go Of the Umbilical Cord*

*And When I Brought Home My Very First "A"*
*She Took Me To Celebrate That Very Special Day*

*Then Came the Day I Put Away the Toys*
*I Traded In My Barbie; for An Interest In Boys!*

*Mama Said, "Stay in School - Make Something of Your Life"*
*And Then He'll Respect You; and Make You His Wife*

*Now, I'm All Grown Up With Children of My Own*
*My! Oh My! How the Time Has Flown!*

*And Now It's Time for Me To Pay The Ultimate Price*
*I Pay Tribute to You for a "Mother's Sacrifice!*

## 2. My Aunt, Marian W. Ward

My Aunt Marian (Auntie) was intelligent, congenial, compassionated, hospitable, a great orator, and a great teacher of wisdom. As I previously mentioned, I moved to Washington State during my senior year in high school. Tremendous adjustments had to be made in my life in a short span of time. I shared a room, with my cousin Shaun, which was my biggest adjustment. Shaun became my shadow; almost everywhere I went, I had to take him with me. He also was a little parrot, repeating everything he heard.

Even though this was an unsettling time for me, Aunt Marian was my bright light in a dark situation. Auntie had a quiet, gentle, spirit; very seldom did she raise her voice. She always greeted me with, "Hi Niecy-Niecy"! She was attentive to my desires; and gave space for me to unleash my bottled up emotions of bitterness, anger, sadness, and disappointment. Auntie was like a warm blanket on a cold, wintry night; she enveloped you with passion and sincere care. I could openly and honestly express my feelings to her without reservations. Aunt Marian was the type of woman who would see a homeless person on the street and give him/her a place to stay. I remember a lady and her daughter who she took in because they had no place to live.

My Auntie did not have an abundance of material goods or money, but such as she had; she shared without hesitation.

Aunt Marian was a very sensitive woman; you could very easily hurt her feelings with negativity. She despised conflict and would go out of her way to avoid it. Auntie was quick to offer an apology; she did not hold grudges (Maybe that is truly where I learned the art of forgiving.). She was not perfect; like many of us, she had her faults. However, she did not ostracize, nor did she try to make others accept her faults; yet, she refused to let others dictate her life.

On many occasions, Auntie served as a mediator between me and my mother. My mother was very strict and there were times that I just needed a little slack in her noose. I would talk to Aunt Marian and ask her to talk to my mother. She would always give it a shot--sometimes it worked, sometimes it did not – but I always admired her courage to initiate the action.

Aunt Marian was not a religious woman who went to church every Sunday, but she had more love in her little finger than most people I know in any capacity. If love is the criteria for obtaining life eternal, and if the statement of the songwriter who penned the words *"They will know we are Christians by our love"* is an accurate definition of Christians; then Aunt Marian is certainly at the top of her class. She loved even when others did not display love to her. She asked for forgiveness even when she did nothing to warrant the action of forgiveness. Auntie loved those whom most people would not have given the time of day. The day that she exited this life, left a void in my life. My means of unconditional expression moved from a person to a pen. I miss her dearly, however; the pearls of wisdom that she has imparted in my life can never be taken away. My passion for life is generated from her passion for life. As I grow older, I take on her position of not letting others dictate my life. My life is so much richer because of you, Auntie – Rest in Peace! I know that you are still watching over me – my guardian angel, my love!

### 3. My Aunt, Janet Ellis

My Aunt Janet Ellis, twin sister to Aunt Jackie, was a woman of valor and courage (I believe I inherited these traits from her). Acquainted with struggle and hard times, she took the blows of life with the dignity and courage of a prize fighter! Aunt Janet stood up for a cause--even if it cost her natural life.

My cousin Rita and I spent several summers with my Aunt Janet and my cousins, Nina and Margie. We all slept in the same bed and some mornings I woke up soaked, after Nina wet the bed. Aunt Janet always made light of Nina's uncontrollable bladder fiascos by telling us it was "just a little pee".

Both my aunts, Aunt Marian and Aunt Janet died of cancer, but Aunt Janet's death, at the young age of 34, was more tragic to me for a couple of reasons. First, I did not think that she had to die (I will explain later). Secondly, I did not attend her funeral so I felt robbed of the opportunity to officially say goodbye.

Aunt Janet passed the same year that I moved to
Washington State from Texas, during my senior
year in high school.  During the time of her
passing, I was selected to represent my school, Mt.
Tahoma, in the City's Afro-Princess Pageant
(Hmm-m, I had low self-esteem at that time but I
guess others saw something different.)  My mother
spent a sizable amount of money buying my
evening gown and the associated props and
accessories necessary for the pageant.
Unfortunately, she could not afford to purchase an
airline ticket for me to attend the funeral.  In fact,
the pageant and the funeral occurred on the same
day, March 26, 1977.  The guilt of that dilemma
haunted me for many years; that date is forever
etched in my memory bank.  I still cry when I hear
Boyz II Men sing "It's So Hard To Say Goodbye To
Yesterday".  *"And I'll take with me the memories to
be my sunshine after the rain!  It's so hard to say
goodbye to yesterday."*  Yes, I do have my
memories – some fond; some painful.  The fond...,
My Aunt Janet loved the late crooner, Jackie
Wilson.  I remember watching as Mr. Wilson
swayed his hips on the Ed Sullivan Show, on my
grandmother's 13-inch black and white television
set, with the rabbit ears.  I can hear his smooth
voice belting out *"Come out here on the floor!  Let's
Rock some more...Work baby, Work Out!"*  And I
can visualize my Aunt Janet screaming hysterically
as if she was going to pass out at any given moment,
mirroring the girls on the television set who
screamed and literally passed out.

And the painful..., I remember the day that I was
dismissed from the room as my parents, uncles, and
aunts sat at the kitchen table in our home for a
family meeting (children were not allowed in the
room when grown folks talked).  Curiously, I
eavesdropped in the hallway, hoping that
something would be said to reveal the reason for

the gloomy faces that my relatives displayed. My heart was not ready to hear the news that rolled off my Aunt Janet's lips, "I have breast cancer!" And then, I heard the sobs of my uncles and aunts and realized that there was something terribly tragic about that revelation. In the early 70s, little was known about breast cancer, especially in the African-American community. We were familiar with heart disease, high blood pressure, and "sugar" diabetes, but not breast cancer. Cancer was primarily associated with cigarette smoke, and my Aunt Janet was a smoker. So, my logic told me that if Aunt Janet would just quit smoking then she would be cured and that would be the end of it. Little did I know of the painstaking battle that she would fight in the next few years, right up until her dreadful death, in 1977. Her plight included a drug addiction to morphine, which brought forth erratic behavior and landed her in a mental institution, and an introduction to a religious affiliation that left us all in a state of confusion and grieve. My Aunt Janet became indoctrinated into the Jehovah Witness religion whose belief prohibited blood transfusions. "The 2001 textbook *Emergency Care* under Composition of the Blood," stated: "The blood is made up of several components: plasma, red and white blood cells, and platelets. Thus in line with medical facts, "**Witnesses refuse transfusion of whole blood or any of its four primary components**"." [27] At the critical stage of my Aunt's cancer treatment, after chemotherapy and radiation failed, the doctor stated that the only recourse was for her to have a blood transfusion. As a devout Jehovah Witness; Aunt Janet refused. My father, aunts, and uncles tried to persuade her, yet; she stood her ground. They even considered having her declared medically incompetent to make decisions due to her illness and the heavy dosage of medication administered to her; but it did not work. My aunt's religious belief was her first priority and

she was willing to die for what she believed; and she did just that – died for it. Our family struggled and suffered the repercussions of that decision for many years. Yet, a couple of years ago, I found a measure of courage in her stance, no matter how illogical and fruitless it initially appeared. I realize it is similar to the stance that I have taken with Christianity; it is a lifetime commitment for me, though my loyalty has not been tested with death. During one of my visits to Washington State, my uncle, who is Muslim, asked me a question – he inquired, "What if you died and found out that there was not a heaven and all the principles and beliefs you adhered to and lived by were not true?" My answer was, "I'd rather live this life and die to find out that Heaven is not real than not to live this life at all and find out Heaven IS real and I cannot enter in!" This Christian life that I live is a good life. It is a life that does not cause me any harm. It is a life that promotes love and not hate. It is a life that encourages strength and not weakness. It teaches me how to be a giver and not a taker. So, what do I have to lose? I have also settled in my mind that we all have an appointment with death and none of us can circumvent that appointment. *("And as it is appointed unto men once to die,* **but** *after this the judgment!"* **[Hebrews 9:27]).** Besides, who can truly say that the blood transfusion would have saved my aunt's life? That question will never be answered. Maybe Aunt Janet's persistence was her way of saying, "I'm tired and I have suffered enough!" I was not there during her final stages of cancer but one of my cousins described how her body was covered with infectious sores. Maybe she had made a choice to end her suffering! Or maybe she was making a declaration like the Apostle Paul, *"I have fought a good fight, I have finished my course, and now there is laid up for me a crown of life."* At any rate, it is finished! Even though my Aunt

Janet departed this life 31 years ago, the love and memories, which I hold dearly in my heart, will never be forgotten. I am a product of her gallantry and I will pass on her legacy to my daughter!

I am so proud of my ancestry; I come from a lineage of very strong, intelligent, beautiful, wise, and spiritual women who were instrumental in guiding me and preparing me for my destiny; I am so grateful. There are many others who I could highlight here, My Grandma Lola, Aunt Helen, Aunt Jackie, and my Aunt Carolyn, who equally inspired and touched my life, as well. Another woman, who was like family, who touched my life was my late pastor, Georgianna Smith, she gave me spiritual foundation. Time would not permit me to write about all of them, but each one of them has deposited tidbits of wisdom in my life that has made me the proud, Black Woman that I am today. I take my hat off to you; you provided the compass for the journey!

# WORSHIP
## (The Core of Our Existence)

*"Worship the LORD your God, and his blessing will be on your food and water. I will take away sickness from among you, and none will miscarry or be barren in your land. I will give you a full life span [Exodus 23:25-26 NIV]."*

In our beginning chapter entitled, *The Red Dragon*, we discussed birthing of the promise by the Great Wonder. Our reference scripture above also refers to the birthing process, assuring us that we will not "miscarry" if we "Worship the Lord". We were born to worship Him; it is the core of our existence. What is worship? "The English word "worship" comes from the old English word: *weorth,* which means "worth," When we worship, we are saying that God has worth, that He is worthy." [28] So, since God has worth, then I have worth, because He is my Creator.

Most often, we associate the term worship with an entire church service or a segment within the service, referred to as "Praise and Worship". This period of adoration is usually led by a group of singers whose specific mission is to usher the congregation into a global expression of worship. I really enjoy this act of jubilation within the service; however I do not believe it reflects the full embodiment of "true worship". Upon researching the topic on the Internet, I found a website entitled, *gotQuestions?org*, that validates and clearly expresses my sentiments concerning worship. It informs:

*"Music as such has nothing to do with worship. Music can't produce worship, although it certainly can produce emotion. Music is not the origin of worship, but it can be the expression of it. Do not*

*look to music to induce your worship; look to music as simply an expression of that which is induced by a heart that is rapt by the mercies of God, obedient to His commands.*

*True worship is God-centered worship. People tend to get caught up in where they should worship, what music they should sing in worship, and how the worship looks to other people. Focusing on these things completely misses the point. Jesus tells us that true worshipers will worship God in spirit and in truth (<u>John 4:24</u>). This means we worship from the heart and the way God has designed. Worship can include praying, reading God's Word with an open heart, singing, participating in communion, and serving others. It is not limited to one act, but is done properly when the heart and attitude of the person are in the right place.*

*It's also important to know that worship is reserved only for God. Only He is worthy and not any of His servants (<u>Revelation 19:10</u>). We are not to worship saints, prophets, statues, angels, any false gods, or Mary, the mother of Jesus. We also should not be worshiping for the expectation of something in return, such as a miraculous healing. Worship is done for God—because He deserves it—and for His pleasure alone.*

*True worship is felt inwardly, and then comes out through our actions. "Going through the motions" out of obligation is displeasing to God and is done completely in vain. He can see through all the hypocrisy, and He hates it.* [29]

When we take the focus off of our inner struggles and problems, and focus our attention on our Deity with reverence and adoration; we will find that our disposition changes, because we put Him at the core of our existence. It

is nearly impossible to truly worship God and remain depressed. It is, at the very least, difficult to remain hopeless and in despair after worshipping God. It is unfeasible to think on the blessings of God and the curses at the same time. It is impossible to be on the high- end and low- end of a see-saw at the same time.

Worship does not exempt us from trouble; however, God said that He would keep us safe during those times of tribulation. The dragon (enemy) does not like it when we worship God because he knows that he cannot touch or find us when we enter in the sanctuary (place) of our worship. The reason is because, during our time of worship, the Glory of the Lord fills the temple and covers us. He (the dragon) is unable to see us in a smoke-filled room.   Psalm 27: 5-6 states:

*For in the day of trouble He will keep me safe in his dwelling; He will hide me in the shelter of His tabernacle and set me high upon a rock.*

*Then my head will be exalted above the enemies who surround me; at his tabernacle will I sacrifice with shouts of joy; I will sing and make music to the LORD. [NIV]*

When you worship God, and reverence Him for all the things He has accomplished in your life, there is an expression of adoration and honor that lifts you higher and higher. When I think about all the wonderful things that He has accomplished in my life; I cannot help feeling joy and gladness in my heart. Sometimes, I get teary-eyed when I think of where I could be if He had not blessed me— homeless, hungry, lonely, broke, rejected, heartbroken, and hopeless.

Worship replaces the dragons in your life.   Let us complete a quick exercise!   Take out a sheet of paper and write down

all the wonderful Names of God and how each relates to your life. Let me help you get started with a few names: *"Wonderful Counselor, Mighty God, Everlasting Father,* and *the Prince of Peace"*. Secondly, assign each of your dragons to a Name of God. Assign "The Dragon of Impatience" to **"The Prince of Peace"**. Assign "The Dragon of Martyrdom" to **"The Everlasting Father"**. Assign "The Dragon of Arrogance" to **The "Mighty God"**. Trust Him to slay the dragons in your life, and then worship Him. If you practice this concept continuously, you will certainly overcome the dragon of low self-esteem. *"Exchange" will produce "a change" in your life*. The key to your redemption and transformation is found in your worship-- a God-centered life. Tell God how important He is to you! Let Him know that you are lost without Him! Tell Him that "He is the air that you breathe!" Bow, kneel, raise your hands, lay prostrate before Him, and worship Him. He will lift you higher during the journey....!

## MILLIONAIRE MENTALITY
## (As A Woman Thinks..!

*"A mind is a terrible thing to waste!" [United Negro College Fund]*

A few years ago while working as a government contractor, I met a very arrogant and self-centered "player" or so-called "Casanova", who incidentally was married. His marital status did not prevent him from flirting with what he classified as--and I quote, "beautiful women". His forwardness disgusted me so I went out of my way to avoid him and his "over-the-top" comments. He stared at you as if you were a biscuit in maple syrup that he wanted to sop up! It seemed that the more I ignored him, the more attraction he felt. One day, he came to my cubicle when no one was around, and asked me what it would take for me to return his advances. I replied, "That will never happen because you cannot afford me!" Curiously, he asked me how much was I worth? I replied, "Millions, so you could never achieve the mental capability to ever relate to me!" I stared him straight in the eyes, (it is something about staring the dragon right in the face) and he looked stunned. I know my answer sounds harsh, but there comes a time when we have to take a stance and let the dragon know that we will not be swayed by his "cheap" tricks or wooed by his "bargain-basement conversation"! Ladies, we are worth more than a "15-minute, cut-rate thrill" with a man of low standards. Do not waste your time on dead-end and dead-beat relationships.

Do you know that about 1/3 of lottery winners experienced bankruptcy because they were not mentally prepared to manage millions? Some of you are in "bankrupt" relationships—there is no trust, no respect,

no communication, and no intimacy because you amalgamated with someone who is not accustomed to managing millions (you). You want to stay at the *Ritz-Carlton*, and he prefers *Motel-6*. You want to dine at *McCormick and Schmicks,* and his idea of a great meal is at the "Mom and Pop" diner tucked away in a "hick" town, in the middle of nowhere. Now, I am not snubbing my nose at anyone's choices—whatever "floats your boat" is fine by me; however, this is just a literal example of a bigger equation, for the sake of visualization. My point to this whole illustration is based on a scripture in Amos 3:3 in *The Message Bible, "Do two people walk hand in hand if they aren't going to the same place?"* Ladies, we have to start thinking on a higher dimension. A millionaire becomes rich in his mind before he actually receives the millions. Besides, when you start thinking like a millionaire, you will be prepared when the millions appear. Many of us are "overdrawn" in our relationships because out liabilities outnumber our assets, when we compromise our worth.

Ladies, oftentimes, ***we attract what we reflect***. The other night, I was channel surfing and landed on a paparazzi celebrity gossip show. A very popular actor/comedian/singer was captured on camera asking the phone number of a "groupie". The "groupie" wore a very low-cut and hip-hugging dress that exposed her full-cupped breast, and outlined her oversized rear end. Now, it is my guess that this actor was not basing his selection on the fact that this woman looked like a great conversationalist in which he desired to discuss world politics. I would guess that his motive was a little more personal – like "pillow talk". It is absurd to put yourself in that position, if that is not your desired results (pillow talk) and if you are looking for something more permanent (such as a relationship); which, I assume, most groupies desire. Some groupies follow their misguided fantasy of instant "fame and fortune". Groupies, I caution you, do not be heartbroken or offended if the only place that this celebrity wants to be

seen with you is in his hotel room. Do not feel rejected and despondent when he does not call you for a second interaction. According to the rappers, if you want to marry a "baller", you got to be a "shot caller". You have to navigate your own ship. Simply put, you have to *"project what you expect"*. If you want to be a millionaire—think and act like a millionaire. You have to go to the places millionaires go, eat what millionaires eat, dress as millionaires dress, and speak as millionaires speak. Millionaires are treated differently from ordinary people. One night I watched an episode of the reality show, *Being Bobby Brown,* where celebrities Bobby Brown, Whitney Houston, and their family members stayed overnight at a very upscale hotel. Although Bobby's and Whitney's behavior was "ghetto" (talking extremely loud and using profanity), the hotel staff treated them with the utmost respect, offered them the best accommodations and premium service, because they knew that they were millionaires. When you have millionaire mentality, your status alone demands a measure of respect. That is why I boldly let that "Casanova" know that I was offended by his advances, because he was disrespecting my millionaire status. As a result, he immediately changed his approach towards me; he changed his conversation and behavior and stopped the lewd remarks. Later on that day, as I sat on the other side of his cubicle (although he was unaware that I was there), I heard him tell someone on the phone about our conversation and how I told him that "I was worth millions". When you stand up and truthfully speak against the dragon, it leaves an inerasable imprint on his forehead; it confounds him. You may not immediately see the outcome, but believe me—he cannot stand the truth.

So ladies, it is not how low you can go; it is how high you can soar! Aim high! As my role model, Tyler Perry says, "Dream Big!" A friend of mine, Kristi Luv Wilson, the author of the book, *Driving Destiny,* wrote a poem that I would like to share with you entitled, Dream Again". If

you have been sidetracked and low self-esteem has caused you to lose focus of your dreams; you can "Dream Again!"

*Dream Again* – Kristi Luv Wilson

**Deep within my heart I strive to achieve**
**The greatest gift imaginable**
**My ability to dream**
**For I am a sum total of all of my experiences**
**Therefore, I do not take them lightly**

**Rather, I embrace the very core**
**Of that which makes me whole**
**For I know if I work hard**
**I can someday achieve my goal**
**For life is everything beautiful**
**And has endless circuits of meaning**
**But it is only when I am willing**
**That I can keep on dreaming**

**The dream is bigger than any nail in my hand**
**And for that reason alone I must follow the plan**
**The blueprint is simple but staying the course**
**gets rough**
**But I will not detour even when the going gets**
**tough**

**Instead, I will meet the day with a smile and a**
**grin**
**And I will tell myself, "_____" you can**
**win**
**For you were destined to be all that you wish to**
**achieve**
**All you have to do is continue to believe**

**So don't stop dreaming or climbing the**
**mountains of life**
**For it is when you feel like giving up that things**
**will start to seem right**

**This is when you will know that your climbing
isn't in vain
So renew your hope and see the beauty in the
plan
Simply put, my friends, we can all dream again!**

Dream big my friends!  Do not let anyone treat you less
than the millionaire you are!  Demand millionaire
treatment and speak and act in accordance with the
dreams that you desire to achieve.  You can achieve
prosperity if you climb up to the top of the mountain and
accept nothing less than the best on the journey...!

# SELF-GRATIFICATION
## (Loving The Skin You're In!)

*"For <u>bodily exercise</u> profiteth little..." 1 Timothy 4:8a [NKJV]*

Oprah Winfrey, Kelly Price, Kirstie Alley, Star Jones, Mary-Kate Olsen, Nicole Richie, and Karen Carpenter--- each of these ladies share a common denominator— weight issues. Most of us could add our names to the list, whether we feel that we are too fat or too thin; it is still a grave issue. In my opinion, this is one of the greatest contributors to low self-esteem. Many of us spend too much time trying to change our looks. Very few of us embrace and love the skin we are in!

At the start of a new year, countless women and men flood to the local gymnasiums to fulfill that annual "New Year's Resolution"--to shed those unwanted pounds. Women of all shapes and sizes stand in long lines for their opportunity to walk briskly on treadmills, bounce on oversized balls, exercise to upbeat music in aerobics classes, and firm their physique in the weight training zone. We usually continue this routine for a few weeks or so, and then we are back to business as usual, until the next New Year's Resolution. Wasted time and wasted money and why? The answer is simple—conformity to society's standard. According to the National Health Statistics, the average height for a woman is 5'5", and the average weight is from 117 to 130 pounds. I believe these standards are based on a specific race and are not universal. The body composition for a Caucasian woman with no hips is quite different from an African American woman with much hip. Therefore, who is to say what is "standard"?

At one point in my writings, I questioned the significance of this chapter on weight and self-gratification; however,

two television shows that I viewed this week, changed my opinion. The first was an episode of *The Oprah Winfrey Show*, which dealt with how other countries defined beauty. "Thin is definitely in" in Brazil! The ladies there spend a vast amount of money on plastic surgery and Botox. According to a guest on the show, Iranian women have an obsession with their noses and spend a considerable amount of money on plastic surgery, also. The most diverse definition of beauty was found in a country in West Africa called, Mauritania. In Mauritania, "plump is sexy". In fact they practice gavage, better known as "forced feeding", to make the young ladies fatter and more desirable. They stuff these young ladies with couscous and milk until their stomachs are so full that they vomit. After the vomiting, the women start the "force feeding" again. Thin women are classified as "sick" in Mauritania and are not suitable for marriage. In Mauritania, thin women are probably the ones with low self-esteem. My point being, beauty is defined differently depending on the region in which you live. I guess we can reiterate that, "Beauty is in the eye of the beholder!"

Focusing on weight can truly affect one's confidence level. The second show that I viewed this week was a reality show found on the CW network entitled, *Stylista*. *Stylista* follows the competition of a group of fashion lovers seeking the opportunity to work for the fashion magazine, *Elle*. The contestants are divided into teams. Each week the teams are given a challenge to impress the fashion news director of *Elle*, Anne Slowey. The least favorable team stands in jeopardy of one member of the team being eliminated. On the first show the contestants were introduced. One of the contestants was a full-figured brunette named Danielle; who had a great flair for fashion; and seemed to be very self-confident. Due to other commitments, I missed about three or so episodes and decided to tune in last night. The editorial task was to select clothing from *Elle's* closet in preparation for a party where the contestants would host a "meet and greet". This posed a problem for Danielle because there

was no plus size clothing in the closet. The once seemingly-confident Danielle, who stood tall in the first episode, now cowered on the floor crying, four episodes later, because there were no clothes to fit her. On top of that, she asked two of the smaller contestants what they thought about her size. Bad idea! One of the women said that high fashioned clothes looked better on "tall, thin women", and that she thought that they (thin women) were more attractive. Poor Danielle! The insecurity concerning her weight, which she tried so hard to mask, became transparent. She also fell for the oldest trick in the book; she asked her competitor/dragon to validate her fear. The object of the show was to eliminate the competition so that the last person standing would receive the position as editorial assistant for *Elle* magazine. This woman did what any rival would do—she went for the Achilles' heel of her opponent. Since Danielle verbalized her insecurity about her weight by asking this self-destructing question, she opened up "Pandora's box", succumbed to the attack, and was sent home.

This is a cruel, cruel world when it comes to prejudices on weight. In the United States, we are "brainwashed" to believe that "thin is better". Very thin supermodels parade the runways projecting the image of the acceptable size. Even the label "plus size" indicates some type of abnormality. Plus what? The same "so-called abnormality" is seen as the standard of beauty in Mauritania! Wow, what a mix up! That is why I say, "Love the skin that you're in!" Let me interject; however, if the skin you're in is causing you some health issues, then perhaps you have over- or under- managed your weight. Obesity can cause serious health risks! According to WIN (Weight-control Information Network), *"Many serious medical conditions have been linked to obesity, including type 2 diabetes, heart disease, high blood pressure, and stroke. Obesity is also linked to higher rates of certain types of cancer."* [30] In contrast, anorexia nervosa is just as risky and could be deadly! *"Anorexia nervosa is a complex psychological*

*illness that can have devastating physical consequences.
Twenty percent of anorexics die of their illness, many
from heart attacks and starvation."* [31]

Ladies, I understand the overbearing need of conformity
to weight standards. I was married to a man who told
me that if I gained weight; he would divorce me--and he
was serious. I ate so many grapefruits to maintain my
"size 10" dress size that I experienced acid reflux.
Sisters, it is manipulation and control when someone
threatens you to maintain your weight; you have to be in
control of your own body. The Apostle Paul instructs us
to be content in whatever state we are in:

**"I am not saying this because I am in need, for I
have learned <u>to be content whatever the
circumstances</u>. I know what it is to be in need,
and I know what it is to have plenty. I have
learned the secret of being content in any and
every situation, whether well fed or hungry,
whether living in plenty or in want. I can do
everything through him who gives me
strength." [Philippians 4: 11-13 NIV]**

Ladies, learn to love the body that God gave you!
Whether tall, short, fat or thin; love the skin you're in!
Remember that you are "fearfully" and "wonderfully"
made (Psalm 139:14). You are beautiful inside and out!
Do not let the media, magazines, and music moguls box
you into a standard of beauty. Beauty comes in all
shapes, colors, and sizes! See yourself beautiful! Face
the journey...!

# SELF LOVE
## (Expelling Suicidal Thoughts)

*"Learning to love yourself is the greatest love of all!" George Benson/Whitney Houston*

"Learning to love yourself"....seems like a simple task! Most of us are decent, fun-loving, moral, and likeable people, so why would anyone have a problem loving oneself? We take care of our physical appearance—fixing our hair, getting our nails and feet groomed, wearing stylish clothes, and splashing on our favorite perfume; but, what about when we disrobe and stand face-to-face without the mask of textile and the superficial covering of makeup and accessories, can we stand erect, look at ourselves in the mirror, and like what we see? Are you constantly comparing yourself to someone else because you would rather be anyone other than yourself? Some of you have pretended to be someone else for so long that you no longer know the real you! "Will the real _____, please come forth?"

Ladies, have any of you loathed yourself and your life so badly that you made a decision to take your life? Suicide, what an ugly word! In 1999, suicide was the 3rd leading cause of death among young people 15 to 24 years of age, following unintentional injuries and homicide. [32] According to researchers, the suicide rate for middle-aged women in the United States is on the rise. The increase in the overall suicide rate between 1999 and 2005 was due primarily to an increase in suicides among whites aged 40-64, with white middle-aged women experiencing the largest annual increase (3.9 percent increase).[33] Although researchers conduct their studies according to gender, race, and demographics, suicide does not discriminate; it sees no color, race, age, or gender.

Personally, I could have been included in the statistics of teenage suicide in the 1970s, when I first attempt suicide. I mentioned that I gave my "first love" my virginity for a Christmas present. Well, you know what happens when you have unprotected sex; eventually, you find yourself in a situation. Yes, I became pregnant! Though I tried to conceal my plight from my parents, my mother was very in tune to the time period that my menstrual cycle should occur. Realizing that I had skipped my normal cycle, she began to question me. I have never been a good liar, (even though I tried); eventually, my secret was revealed. This was a very dark and dismal part of my life. The disappointment and mistrust that my parents expressed and the depression that I experienced, knowing that I let them down, was much more that I could bear. So, I took a bottle of Acetaminophen (Tylenol), washed it down with acetone (better known as finger nail polish remover) mixed with Coca Cola (Oh, how it burned my chest going down!), and then, waited for me and my child to die. My saving grace was that I confided in my cousin concerning my suicide attempt--she told my aunt, and my aunt informed my mother. Hours later, as I lay in bed, my mother burst in the door, asked me what I had done, made me get up and dress, and my parents, along with a friend of the family, rushed me to the hospital (this was before the period of having access to 911 for emergencies). When I arrived at Polly Ryan hospital (seven miles away), the doctor examined me and determined that there was no need to pump my stomach since hours had passed and nothing had happened (Thank God for the Mercies of God). No harm was done to me or my baby! Although my suicide attempt was thwarted, the depression and low self-esteem remained. The doctor at the hospital recommended counseling; however, counseling is not well-received in the African American culture. Only crazy people sought counseling, not misguided teenagers like me. I think I attended one session and that was the end of it; I never returned!

The next revelation is a painful one for me, concerning the baby I was carrying. I was given the choice to abort my baby, which would give me the opportunity to finish school, go to college, and find a good career; or keep the baby and lose my freedom, college, and career aspirations. As a sixteen-year old teenager, I did not have the mental capacity to make such a life-changing, adult decision. Considering the options that were placed before me, I made the decision to have an abortion. Ladies, abortion is murder, and no matter how the pro-abortionists try to distort the lingo by calling a baby, "a fetus", it is still a life. At first, I believed that I suffered no emotional damage from my abortion because I convinced myself that he/she was a fetus, as well. I never discussed how the abortionist suctioned the baby out of me! Or, the extreme cramping and bleeding I experienced! I simply endured it all! Two days later, I returned to school and resumed my normal life; if you could call it that! I never mentioned or discussed this tragedy with anyone; neither did my parents. We all tried to pretend that it did not happen.

A few years ago, as I was reflecting on my past, I rewound and paused at this incident, and began to cry uncontrollably. An overwhelming stream of emotion began to flood over me like a broken dam. All these years I had locked away the hurt, pain, guilt, and despondency that I felt because of my decision so many years ago. I realized that I suffered from what the medical dictionary described as "emotional amnesia" (psychological etiology [cause] of forgetting or repressing of emotion). [34] Ladies, sometimes we suppress events that cause us the most hurt and pain in order to protect us from mental breakdown, further harm, or even suicide. The website AfterAbortion.org states, "Compared to women who have not been pregnant in the prior year, deaths from suicide, accidents and homicide are 248% higher in the year following an abortion, according to a new 13-year study of the entire population of women in Finland. The study also found that the majority of the extra deaths among women who had abortions were due to suicide. The suicide rate among women who had abortions

was six times higher than that of women who had given birth in the prior year and double that of women who had miscarriages." 35  This could have been me-- I am thankful that God kept me from becoming a death statistic; however, I cannot ignore those who were not as fortunate.  My sympathy goes out to their families.

Ladies, if you are still carrying around the guilt or pain of some childhood act that you committed; you can be forgiven!  Matthew 12:31 confirms, *"And so I tell you, every sin and blasphemy will be forgiven men, but the blasphemy against the Spirit will not be forgiven [NIV]."*  Therefore, abortion [murder] can be forgiven; you do not have to carry that burden any longer!

Back to suicide, I also attempted suicide a few times during my adulthood, as well.  The cause of each attempt was due to some maltreatment/abuse from a man in my life.  Ladies, never put the love of a man above you; no man is worth the price of your life.  For the last attempt, I checked into a hotel room, purchased and drank a portion of a bottle of Courvoisier, consumed several Valiums with the cognac—1 pill, washed  down with a swig of liquor—and so on until all the pills had been consumed.  Then, I laid down expecting to sleep into eternity.  Imagine my surprise when I woke up the next day!  More importantly, I had an experience that morning that changed my life!  I heard a voice in that room that warned, "If you ever attempt to take your life again, I am going to take your life!"  That scared me straight and immediately cured my desire to commit suicide.  It also made me realize that God cared enough to spare my life for such a time as this, and for that I will forever be grateful!  My latter days are so much greater that my former because I have found the secret to a better life.  It is not found in a man, or a job, or in my children!  It is found within me!  Yes, *"Learning to love myself is the greatest love of all!"*  I know some of you "theologians" are probably saying, "Yes, but you have to love God, first!"  Well, Christ is on the inside of me, so if I love me--I love Him!  Colossians 1:27 [NIV] states, *"To them God has chosen to make*

*known among the Gentiles the glorious riches of this mystery, <u>which is Christ in you, the hope of glory</u>.*" The Ragu™ spaghetti sauce commercial uses the slogan, "It's In There!  Well, He is in there! I now have hope because I know my worth! I have examined, identified, confronted, confessed, and disowned every "dragon" that had me bound – disappointment, hurt, guilt, shame, conformity, loneliness, co-dependency, fear, doubt, anger, bitterness, unforgiving, disillusionment, heartbreak, control, manipulation, murder, infidelity, pessimism, deceit, and abandonment. Each of us has our own dragons to slay. I caution you, however; slay the dragon--not yourself. Your life is precious, worth more than millions-- NO trillions! There is nothing in this world that is worth taking your life.  You are built to survive and overcome EVERY challenge that is placed before you; but you must not quit. Quitting is not an option!  A famous poem, entitled, "Don't Quit" encourages us to stay in the race of life:

*When things go wrong, as they sometimes will,*
*When the road you're trudging seems all uphill,*
*When the funds are low and the debts are high,*
*And you want to smile, but you have to sigh,*
*When care is pressing you down a bit,*
*Rest, if you must, but don't you quit.*

*Life is queer with its twists and turns,*
*As every one of us sometimes learns,*
*And many a failure turns about,*
*When he might have won had he stuck it out;*
*Don't give up though the pace seems slow--*
*You may succeed with another blow.*

*Often the goal is nearer than,*
*It seems to a faint and faltering man,*
*Often the struggler has given up,*
*When he might have captured the victor's cup,*
*And he learned too late when the night slipped*

*down,*
*How close he was to the golden crown.*

*Success is failure turned inside out--*
*The silver tint of the clouds of doubt,*
*And you never can tell how close you are,*
*It may be near when it seems so far,*
*So stick to the fight when you're hardest hit--*
*It's when things seem worst that you must not*
*quit.*[36]

- Author unknown

Rest but don't quit!  Stay in the journey!

# SELF-ESTEEM
## (The Power to Change Within)

*"Our deepest fear is not that we are inadequate. Our deepest fear is that we are powerful beyond measure."* **Marianne Williamson**

Judge Glenda Hackett usually ends her sessions with her juvenile plaintiffs on the *Judge Hackett Show,* with "I expect greatness!" Some of these teenagers were selling drugs, or their bodies, and were being utterly disrespectful to their parents; however, that hard exterior was a covering for "greatness"! Many of us have allowed life's rough terrains to cause us to be weather-beaten, hardened, and calloused; yet, underneath there is greatness! Hopefully, with the knowledge shared here, you have melted away that stony heart--to a real heart of flesh, which possesses the power to make a change. In order to get to the meat of a coconut, you have to crack the shell; then the milk flows freely.

Ladies, we have come to the end of our road in this book, and it is more important than ever, that you know at this juncture, "I expect greatness!" We have traveled many roads—some steep and winding, some with potholes due to mental "wear and tear", some with precautionary speed bumps to slow us down, and some with detours and road blocks to redirect our purpose. I have shared my heart and allowed you to openly read my life so that you could receive a "close-up" view of the "dragons" that I have wrestled. I pray that you are able to utilize and/or share the knowledge gained. At this point, you should know that you are a queen, adorned with royal linens, and arrayed with precious stones! You should be assured of your beauty and self-worth. With faith in God, you have the power to be and do

ANYTHING. Whether you are in your teens, twenties, thirties, forties, fifties or over--you should have the assurance that you have the **power** to change, enhance, and advance your life. This journey has been equally rewarding for me, as well, because it allowed me to sweep out some of the cobwebs out of my closet and deal with some issues that I had locked away. Together, we have the weaponry —confidence, faith, optimism, prosperity, sisterhood, favor, self-love, and self-gratification--to slay and overcome our dragons. We have purged ourselves inside and out and have shed some unwanted pounds! Now, we can purchase a brand new wardrobe! Now that we have a new wardrobe, we have a new perspective and new dialog. We will speak positive affirmations in our lives. Ladies, sometimes you have to encourage yourself! Do not wait for a man or anyone else to affirm or validate you; build up your own self-esteem. Here is a list of positive affirmations that you can use to boost your self esteem:

- *I deserve to be happy and successful!*

- *I have the power to change myself!*

- *I can forgive and understand others and their motives.*

- *I can make my own choices and decisions.*

- *I am free to choose to live as I wish and to give
  priority to my desires.* 37

Ladies, now that the eyes of your understanding have been opened, walk in the light and have no part of the dark shadows of low self-esteem. A few months ago, I heard a

sermon entitled, *"Not Another Night with the Frogs!"* As the title implies, frogs are nocturnal and love to operate in the dark. You do not have to operate in the dark any longer; walk in the illumination of your soul: ***"I keep asking that the God of our Lord Jesus Christ, the glorious Father, may give you the Spirit of wisdom and revelation, so that you may know Him better. I pray also that the eyes of your heart may be enlightened in order that you may know the hope to which He has called you..." [Ephesians 1:17-18a NIV].***

Ladies, there is hope! The very fact that you have suffered and survived validates the fact that there is hope. According to societal and human standards, many of you have experienced and endured, far worse tragedies than I have and you could write your own books! Some of you have mourned the loss of children; some are widows, some have been molested, raped, or domestically violated; some have experienced major health challenges, physical handicaps, and diseases; some have experienced mental delusion; some have experienced prostitution; some have drug, sexual, and alcohol addictions; some have resided in orphanages and foster homes; some have committed crimes and have been imprisoned; yet; HOPE STILL REMAINS! You may not have fulfilled your life long dreams; you may not reside in the house or neighborhood for which you yearn; you may not have the career or social status to which you aspire; you may not be with the person for whom you long for; yet, THERE IS STILL HOPE! As long as there is breath in your body, there is hope. The great thing about hope--it costs you nothing. The soulful singer India.Irie tells us, ***"There's hope, it doesn't cost a thing to smile! You don't have to pay to laugh! You better thank God for that!"***

Speaking of laughter, some of you need to laugh a little! You are so bogged down with the cares of this life; it shows in

your face! You have wrinkles around your eyes and lines around your mouth, I call these "stress lines". An old fashion quote states that, *"Laughter is good for the soul!"* You need to eat some soul food; take time out to laugh! As I have mentioned, most mornings I listen to the *Steve Harvey Morning Show,* on the radio, so that I can escape from life's challenges for a few hours of the day. Steve Harvey and the morning crew are good medicine for my soul—they are so hilarious. Ladies, it is hard to laugh and be sad at the same time. It is difficult, if not impossible, to laugh and cry at the same time (unless you are laughing so hard that it brings you to tears). I heard an adage that stated that it takes 43 muscles to frown and only 17 muscles to smile. I am blessed with a wonderful smile! In my past, I utilized my smile as a mask for my pain. Now, I utilize my smile as a testimony of my freedom and praise. I am not ashamed of my past; I have hope for my future.

Ladies, there is Power within you! Steve Harvey has repeatedly voiced to the lady listeners on his radio show that the problem with women is that we do not realize how powerful we are! This is so true! If we realized how valuable, significant, special, and beautiful we are, we would not settle for anything less than "greatness". One evening, I watched a very enlightening movie entitled, *Akeelah and the Bee.* This movie depicted a young lady name Akeelah Anderson [Keke Palmer], who lived and attended school in an underprivileged neighborhood, and entered a spelling bee to avoid detention. To her surprise, she wins and advances to the regional spelling bee. Her school principal solicits the help of an English professor, Dr. Larabee [Laurence Fishburne], to coach and prepare her for the regional spelling bee. During their first session, Dr. Larabee makes Akeelah read a partial quote from a profound reading by Marianne Williamson; I would like to share the entire reading with you:

*"Our deepest fear is not that we are inadequate.
Our deepest fear is that we are powerful beyond
measure.*

*It is our light, not our darkness that most
frightens us.
We ask ourselves, Who am I to be brilliant,
gorgeous, talented, fabulous?
Actually, who are you not to be?*

*You are a child of God.
Your playing small does not serve the world.*

*There is nothing enlightened about shrinking
so that other people won't feel insecure around
you.
We are all meant to shine, as children do.*

*We were born to make manifest the glory of God
that is within us.  It is not just in some of us; it is in
everyone.*

*And as we let our own light shine, we
unconsciously
give other people permission to do the same.*

*As we are liberated from our own fear,
our presence automatically liberates others"* [38]

Ladies, we have come to the end of this journey, but it is the
beginning of a new chapter in your life.  We can always
begin new chapters in our book of life.  There are a couple of

chapters that I started writing in this book that did not make the final cut.  I am glad that I have the right to choose what goes in my book, and so do you!  We may not have the power to choose life's occurrences and the sequence in which they occur (if we had those choices, some things we would choose not to experience); however, we do have a choice in how we deal with life's occurrences.  We also have a choice in how we allow those occurrences to affect us!  On this journey, we are going to have some good days and some bad; we are going to have some weary days and some sad!  Ecclesiastes, Chapter 3, tells us that *there is a season for everything under the sun;* those seasons include weeping, laughing, breaking down and building up!  This is the time for you to build up and realize that you are worth more than your weight in gold.  Today is a new day!  "You have only just begun to live!"  I have enjoyed our time together and parting is such sorrow!  I would like to end our journey with the first verse of the closing song from the eleven-year running [1967 to 1978] variety series, *The Carol Burnett Show:*

*I'm so glad we had this time together,*
*Just to have a laugh, or sing a song.*
*Seems we just get started and before you know it*
*Comes the time we have to say, "So long".* [39]

So long, my friend!

## OTHER WORKS BY THE AUTHOR:
## Ms. Vickie L. Evans

### First Book:  The Art of Forgiving
– A relationship tool, based on my triumph over divorce, after my second marriage.  Tools can be applied to any relationship including friendships, employment relations, religious affiliations, etc.  Learn how to separate conflict from the people who initiate the conflict.

### Playwright/Producer/Director:
Gospel Stage Play "A Change Is Gonna Come", depicts domestic violence in the church:  Pastor James Sills is a prominent, well-versed, and popular Pastor, yet, behind closed doors he unleashes an abusive and dark side unto his beautiful wife, Lisa Sills.
Initial debut sold-out at the George Washington Memorial Masonic Temple, Alexandria, Va., June 2007.  In June 2008, nationally premiered at the historic Lincoln Theatre, in Washington, DC.  Advocate in the campaign to stop domestic violence!

### Entrepreneur/Motivational Speaker/Minister:
President of Soaring High Productions – A Faith-Based Talent Promotion Company for aspiring Actors, Authors, Playwrights, and Poets.

**Contact Info:  For book signings, speaking engagements, scheduling plays, etc. contact Author at:  e-mail:  soaring@forgiven2.com, phone: (800) 903-6171  Visit website for more information at:  www.forgiven2.com.**

# END NOTES

[1]http://www.itstime.com/jun99.htm, Information used by permission of Barbara Taylor, Institute of Management Excellence, Derived from "Transforming Your Dragons: Turning Personality Fear Patterns into Personal Power" by Jose Stevens, Bear & Co; (July 1994) ISBN: 1879181177

[2] http://www.merriam-webster.com/dictionary/conceit[1], Definition of conceit

[3] http://www.coffeeresearch.org/market/usa.htm, CoffeeSearch Market

[4] http://www.coffeescience.org/

[5] http://www.azlyrics.com/lyrics/erykahbadu/baglady.html, Erykah Badu Lyrics

[6] http://en.wikipedia.org/wiki/Filet_mignon, Definition of filet mignon

[7] http://en.wikipedia.org/wiki/Filet_mignon, Definition of filet mignon

[8] http://www.answers.com/topic/beset, Definition of beset

[9] http://www.kovideo.net/lyrics/j/Jill-Scott/Hate-On-Me.html, "Hate On Me lyrics, Jill Scott

[10]http://stories.teenfx.com/article.cfm?ar_id=92536&prod=36&sec=6&qz=1&ar=1&pl=1, Haters Quotes

[11] http://www.experiencefestival.com/a/Anointed/id/99013, Anointed: Spiritual - Theosophy Dictionary on Anointed

[12]http://www.pbs.org/wgbh/amex/crash/sfeature/sf_excerpts.html, The Crash of 1929,

13 http://www.merriam-webster.com/dictionary/enterprise, definition of enterprise.

14http://www.christianbook.com/Christian/Books/product_sli deshow?sku=046X&actual_sku=046X&slide=5&action=Previo us, "Understanding Your Potential", Dr. Myles Monroe

15 http://en.wikipedia.org/wiki/Oprah_Winfrey, Oprah Winfrey

16
http://www.infoplease.com/spot/womence01.html#cHughes, Cathy Hughes

17 http://en.wikipedia.org/wiki/Anne_M._Mulcahy, Anne Mulcahy

18 http://www.onlylyrics.com/song.php?id=1004125, "Let Go", Dewayne Woods

19http://www.nytimes.com/2007/01/21/weekinreview/21zerni ke.html?_r=1&oref=slogin, "Why Are There So Many Single Americans?"

20 http://www.kff.org/hivaids/upload/6089-04.pdf, Henry J. Kaiser Family Foundation HIV/AIDS Policy Fact Sheet

21 http://www.topix.com/afam/2007/11/black-divorce-rate-higher-than-whites-or-hispanics-plus-only-42-of-black-adults-are-married. Posted by TheNewsMan Nov 1, 2007

22 http://www.yourdictionary.com/mutual\, Definition of reciprocity

23
http://www.stlyrics.com/lyrics/thebigchill/whenamanlovesaw oman.htm

24 http://www.romantic-lyrics.com/la6.shtml,"Always and Forever", Heatwave

25 http://www.links2love.com/love_lyrics_441.htm, "At Last", Etta James

26 http://www.myhotcomments.com/graphics/42440

[27]http://www.4jehovah.org/downloads/jehovahs_witness/medical/blood4.pdf, Basic Stand On Blood

[28] http://www.wcg.org/lit/spiritual/worship/worship1.htm, "What is Worship, A Survey of Scripture

[29] http://www.gotquestions.org/true-worship.html, gotQuestions?org, What is true worship?

[30]http://www.win.niddk.nih.gov/publications/understanding.htm#Healthrisks. "Understanding Adult Obesity"

[31]http://www.prairiepublic.org/features/healthworks/disordered/anrisks.htm, "Health Risks of Anorexia Nervosa"

[32]http://www.healthyplace.com/COMMUNITIES/depression/related/suicide_8.asp., Healthy Place,Com, Suicide Facts Suicide Statistics

[33]http://www.sciencedaily.com/releases/2008/10/081021093938.htm, Science News, October 22, 2008

[34]http://www.medilexicon.com/medicaldictionary.php?t=2903, mediLexicon, "Emotional Amnesia"

[35] http://www.afterabortion.org/news/suicide205.html, Women 's Suicide Rates Highest After Abortion, New Study

[36] http://www.thedontquitpoem.com/thePoem.htm, "Don't Quit"

[37] http://www.more-selfesteem.com/affirmations.htm, How can affirmations increase your self-esteem?

[38]http://skdesigns.com/internet/articles/quotes/williamson/our_deepest_fear/ , Our Deepest Fear, by Marianne Williamson from *A Return To Love: Reflections on the Principles of A Course in Miracles*

[39] http://www.squidoo.com/carol-burnett-theme-song-lyrics, Carol's Theme

Printed in the United States
217939BV00001B/7/P